WAR REMNANTS of the KHMER ROUGE

MAUREEN LAMBRAY

Essays by

DAVID P. CHANDLER and MARGO PICKEN

UMBRAGE EDITIONS

FOR TOM & LUCY

It was December 1979 when I traveled for Gamma News Agency to the Cambodia/ Thai border where thousands of refugees, many maimed by landmines, were fleeing the fighting between the Khmer Rouge and Vietnamese forces.

On a stopover in Cambodia in 2003, I was stunned to see the continuing effects of the brutal regime of the Khmer Rouge (1975-1979). I began documenting the people and haunted sites.

It seems half the population are still missing arms, legs, fathers or mothers. Those who have lived through the regime are traumatized. Evidence of torture and execution remain in landscapes of beauty. Landmines still surface, killing and maiming people and animals. These factors are some of the major causes of poverty in Cambodia.

The danger of imposing rigid ideologies by an elite group on a nation are evident in the world today. Human rights abuses persist in many countries. The government has begun spiriting away the maimed Cambodians as more tourists flock to their country. We need images as reminders of how quickly genocide can happen, and the past become the present.

Maureen Lambray, New York City

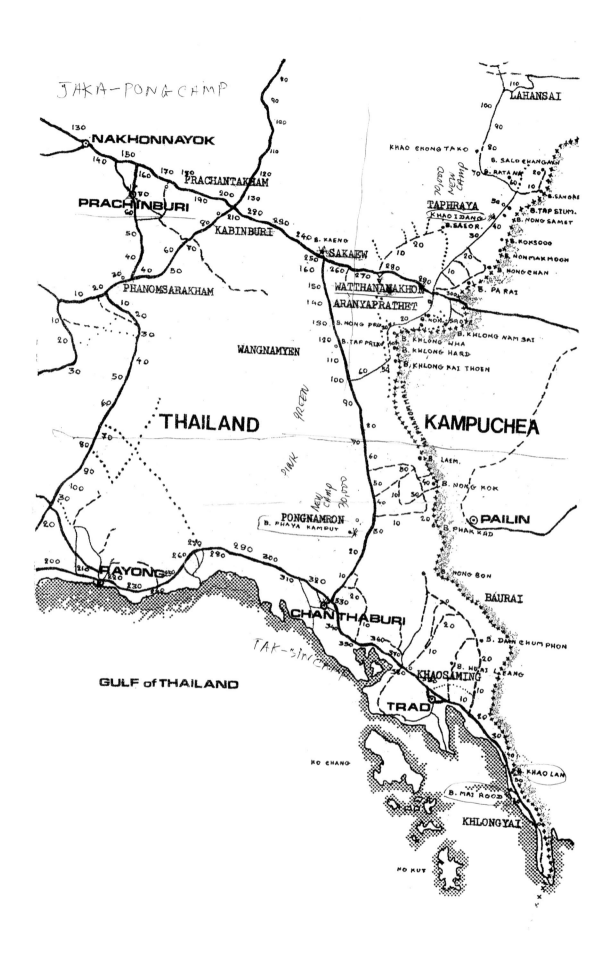

REFUGEE CAMPS ALONG CAMBODIAN/THAI BORDER, 1979.

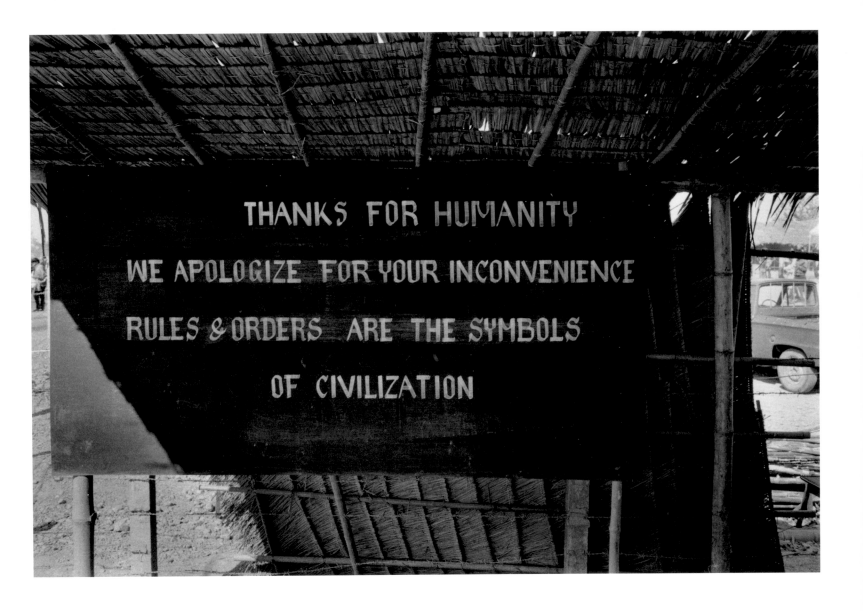

SIGN AT CAMBODIAN BORDER CAMP FOR REFUGEES ESCAPING THE FIGHTING, 1979.

From April 17, 1975 until January 7, 1979, a political tsunami swept across Cambodia, leaving enormous human damage in its wake. Cambodians refer to this period as *samay a Pot,* "the time of the despicable (Pol) Pot," referring to the former school teacher (1925-1998) who was hidden from view but in command of the country.

Precise statistics are unavailable, but in less than four years at least 1.7 million Cambodians, or one in four, died of overwork, starvation, misdiagnosed diseases, grief or executions. The deaths can be traced to the actions and policies of Democratic Kampuchea, DK. On a per capita basis, the 1.7 million figure was the highest death toll of its kind until the genocide in Rwanda in 1994.

This new regime, calling itself Democratic Kampuchea, was controlled by the Communist Party of Kampuchea (CPK), which was concealed from view, along with its leaders, until the end of 1977. In the West, DK was known collectively as the Khmer Rouge, a name that Prince (and later King) Norodom Sihanouk gave to his Communist opponents in the 1950s and 1960s.

Pol Pot, who turned 50 in 1975, was the prime minister of Democratic Kampuchea. To govern the country, he worked closely with a handful of fellow Communists whom he had known and trusted for many years. This collective leadership, the Party Center, shared governing responsibilities with cadre in the geographic zones, an arrangement that produced tensions and purges as time went on and as policies from the center became unworkable anywhere else.

Pol Pot, his colleagues and their followers came to power after five years of ruinous civil war. Whether they were overconfident or terrified by the enormity of their task is impossible to determine, but, almost immediately, for reasons that remain obscure, they forcibly evacuated all the cities that had been controlled by the defeated regime. The largest of these, Phnom Penh, contained more than 2 million people who were driven into the countryside en masse. Untold thousands died in this appalling exodus.

Soon afterwards, governing by decree, the Khmer Rouge abolished money and private property, shut down markets and restricted everyone's freedom of movement. They defrocked Buddhist monks, closed the country's schools and isolated Cambodia from the outside world. They limited diplomatic relations to a handful of friendly countries and rejected foreign assistance (although unpublicized aid arrived from China after 1975). Their aim was to dismantle Cambodian social relations. They hoped to build something entirely new and independent in their place. They wanted to preside over a pure, unprecedented, total revolution. They believed the revolution would succeed by empowering the rural poor, who made up 80% of the population and had never been favored in the past. Unsurprisingly, rural people gave DK its most fervent—but by no means unanimous—support. Former city-dwellers, on the other hand, were labeled "new people" or "April 17 people" and were severely treated. They were often told by CPK cadre, "Keeping you is no gain, losing you is no loss."

Most "new people" were unsympathetic to the revolution and were unaccustomed to agricultural work. They suffered heavy losses in the DK period. Many surviving "new people" have written poignant memoirs of the Khmer Rouge era that have helped to shape our views of "what really happened" in the same way that Ann Frank's eloquent diary shaped some of our ideas about the Holocaust. In fact, what happened to people who didn't write any memoirs was often worse than anything that the "new people" who escaped were eager to remember.

The Khmer Rouge sought to transform Cambodia's hierarchical social relations, small-holdings agriculture and nearly everyone's time-honored and generally conservative points of view. In April 1975, a CPK spokesman declared that "two thousand years of history" had ended. He probably meant that traditional patterns of oppression (urban/rural; rich/poor; master/servant; old/young; king/subject, man/woman and so on) would disappear in the fiery furnace of DK until, he added, there would be "no oppressors and no oppressed." The possibility that a new class of oppressors would replace the defeated ones—which is what happened—never entered Khmer Rouge thinking.

The example of China (and to a lesser extent North Korea) is crucial to understanding the Khmer Rouge, whose leaders believed, like their Chinese opposite numbers,

that they were in tune with what they called the wheel of history. Because China's revolution had succeeded, Cambodia's would succeed as well.

The Khmer Rouge found models for the speed, intensity, and the foreordained success of the revolution in Cambodia's medieval past, when ordinary men and women, who presumably resembled their descendants in 1975, had built the city of Angkor. "If our people can build Angkor," Pol Pot said, "they can do anything." The Chinese Great Leap Forward and the Cultural Revolution, which they assumed had been tremendous revolutionary victories, also inspired the Khmer Rouge. In fact, we now know that the deaths in China associated with these macabre and murderous policies ran into the tens of millions. Pol Pot and his colleagues were unaware that the policies had wrought such enormous havoc. The Chinese only admitted that they had failed long after the Khmer Rouge regime had been driven from power.

As with these Chinese models, it's impossible to give an accurate number of deaths or to measure the traumas inflicted on survivors by "the Pol Pot time." The traumas sprang from the loss of family members, the damage to cultural coherence, the destruction of houses, wats and neighborhoods, and the impact on peoples' psyches of the underlying viciousness and irrationality of the regime. Published accounts, excellent though they are, only scratch the surface of the tsunami that slammed into all the Khmer.

Why had so many people died? They died because the Utopian policies described above were set hastily in motion by the untrained, recently empowered men and women, emerging victorious from a civil war, with no experience of governing a country. The fact that the revolution was without precedent, which should have alarmed them, was greeted with enthusiasm. Nothing like this had ever happened before. In revolutionary terms, it seemed, Cambodia now led the entire world. Perhaps the Khmer Rouge leaders felt they had no time to prepare the country for the radical transformation they proposed. The Communist-led revolutions in China, North Korea, the Soviet Union and Vietnam, after all, had taken decades, while the Cambodian version had burst onto the scene on what the Khmer Rouge called the "glorious 17 of April 1975." Haste, thoughtlessness and cruelty in the ensuing years went hand in hand. Ironically, many Cambodians might genuinely have welcomed

some of the changes being proposed after centuries of disdainful, humiliating treatment by the rich and powerful, but the policies were poorly imagined, ineptly managed, cruelly implemented and largely impossible to achieve, leaving the rural poor worse off than they had been before the 1970s.

News of the tragic mismanagement, paranoia and brutality of the Khmer Rouge was slow to reach the outside world, but soon after DK was driven from power by a Vietnamese invasion in January 1979, the nature and extent of what had happened came to the world's attention. Unfortunately, Cold War priorities and international indifference prevented any major powers from doing anything to bring the leaders of the Khmer Rouge to justice, at that time, for the crimes they had committed.

In Phnom Penh, the newly installed, pro-Vietnamese regime, the Peoples' Republic of Kampuchea (PRK), labeled DK "fascist" and "genocidal" and authorized a tribunal to indict Pol Pot and Ieng Sary for the crime of genocide. In August 1979, following a five day trial, the two were condemned to death in absentia, although no evidence was produced that linked them to genocidal policies or behavior. Because so many members of the PRK, including several senior ministers, had been members of the Khmer Rouge, there was little interest in expanding the trial beyond these leading culprits.

Pressure for a more comprehensive trial gathered outside Cambodia in the 1980s and 1990s, but the government resisted it on the grounds that an international trial would subvert Cambodian sovereignty. Eventually, however, a joint Cambodian-international tribunal assembled in Phnom Penh and indicted five surviving leaders of the Khmer Rouge for crimes against humanity. The first to be tried was Khang Kek Ieu, known as Duch, who had been in charge of DK's interrogation center in Phnom Penh, known by its code name S-21. Between May 1976 and January 1979 over 14,000 men, women and children were brought to S-21, suspected of being enemies of the revolution. All but a handful of them were put to death. Duch was found guilty in August 2010 and sentenced to 35 years in prison. The other four aged defendants await judgment.

The Khmer Rouge established the parameters for their Utopian, murderous regime in 1975, and for the next three years they struggled with increasing frustration to achieve the impossible goals they had set. In 1976 they moved tens of thousands of "new people" to the northwest of the country where they were put to work in regions that had never grown rice and told to quadruple pre-war levels of production. Thousands of the newcomers died of starvation, malaria and overwork; and thousands more were summarily executed as "enemies of the state." The cadre supervising them was often blamed for shortcomings and accused, erroneously, of sabotage. By mid-1978 the CPK, never a large party, was tearing itself apart, as its members poured into S-2l on trumped-up charges to be interrogated, tortured and killed.

The final, disastrous years of DK can be dealt with briefly. According to almost all survivors, conditions throughout the country went from bad to worse. Pol Pot's state visit to China in October 1977 led to Chinese assistance that propped up DK for another year, but its days were already numbered, especially after war broke out with Vietnam at the beginning of 1978. Pol Pot and his colleagues, as well as their patrons in Beijing, had always been suspicious of Vietnamese ambitions for Cambodia, and the Chinese had been hostile to Vietnam's alliance with its Communist rival, the Soviet Union. Once war broke out between DK and Vietnam, following a series of provocations on both sides, the Khmer Rouge leaders hoped for Chinese "volunteers," who never came. In desperation, they also tried to galvanize the Khmer with racist slogans, but these had little effect on an unarmed, distrustful and exhausted population. The Khmer Rouge army fought bravely, but it was outgunned, outnumbered and outmaneuvered. When Vietnamese troops invaded in force in January 1979, the country broke open like an egg. Pol Pot and several thousand followers fled to safety in Thailand and the Khmer Rouge regime, like the pro-American one that had preceded it, came unceremoniously to its end.

More than 70 percent of Cambodia's people today are under thirty years of age and had not even been born in the "Pol Pot time." Nonetheless, the multi-faceted impact of those horrified and horrifying years was enormous. As the haunting photographs and their poignant captions in this book so eloquently reveal, unforgettable traces of the Pol Pot years remain.

David Chandler, Melbourne, Australia

WAR REMNANTS of the KHMER ROUGE

MAUREEN LAMBRAY

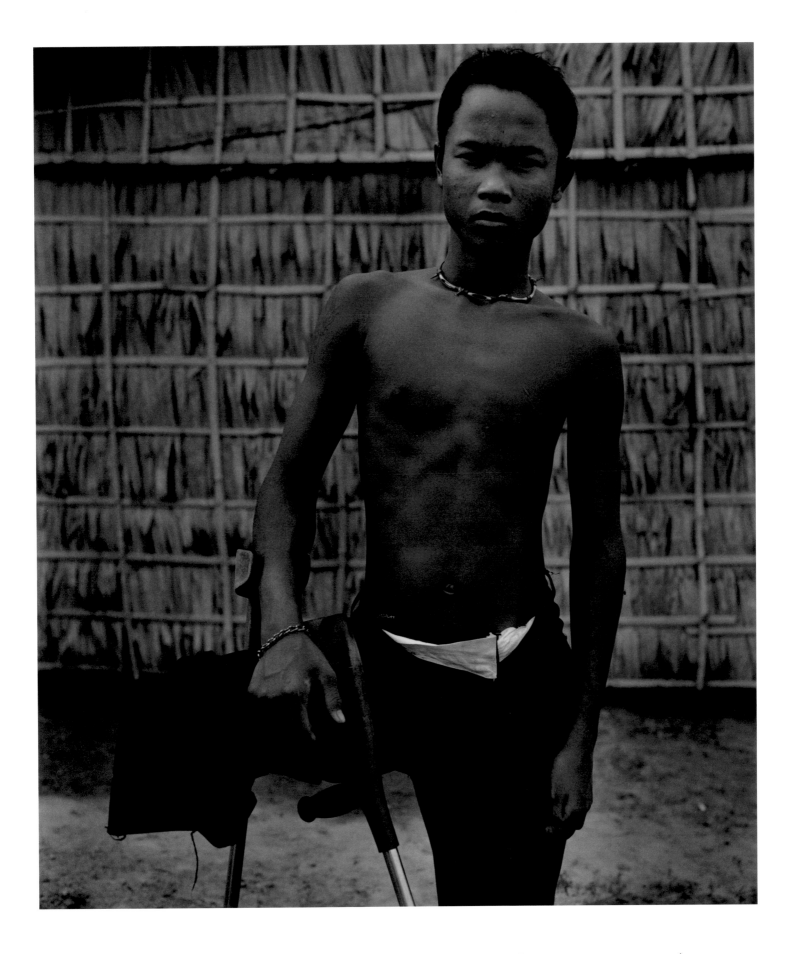

Von Sri - My leg and fingers were blown off while I was collecting
firewood in the jungle. I was thirteen. After that my brother who
is a monk gave me a shoulder tattoo to protect me.

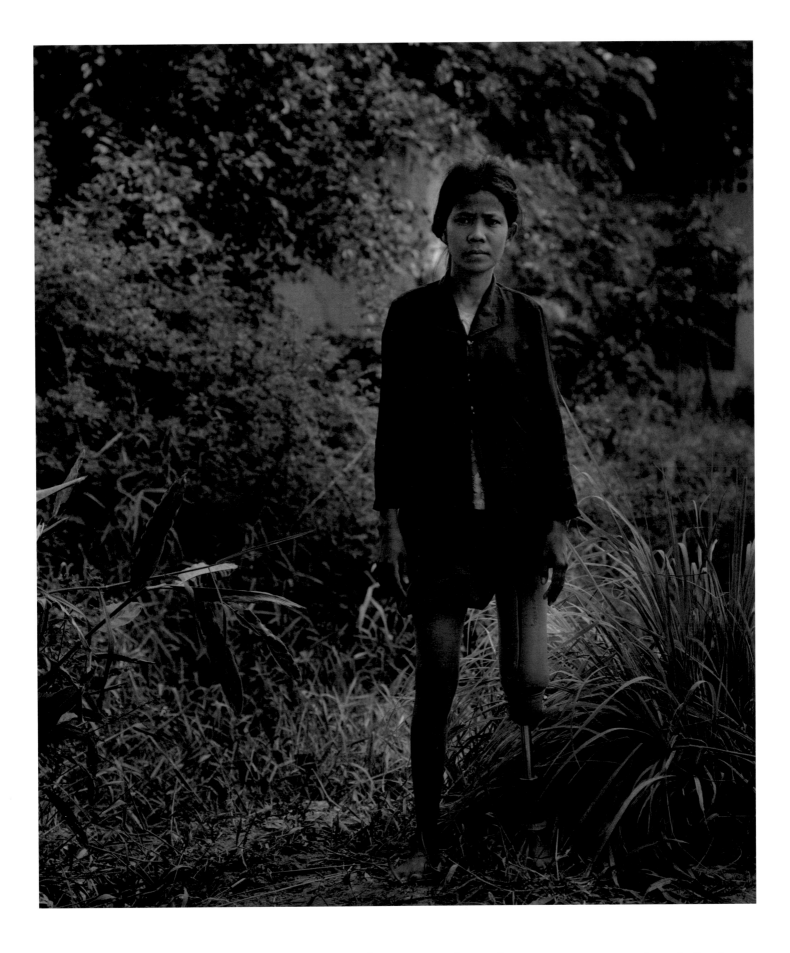

Peurn Clot - I am not married because when I was 18 years old I lost my leg to a landmine. In the countryside where we are very poor the men look for a woman who is either strong or rich. I am neither.

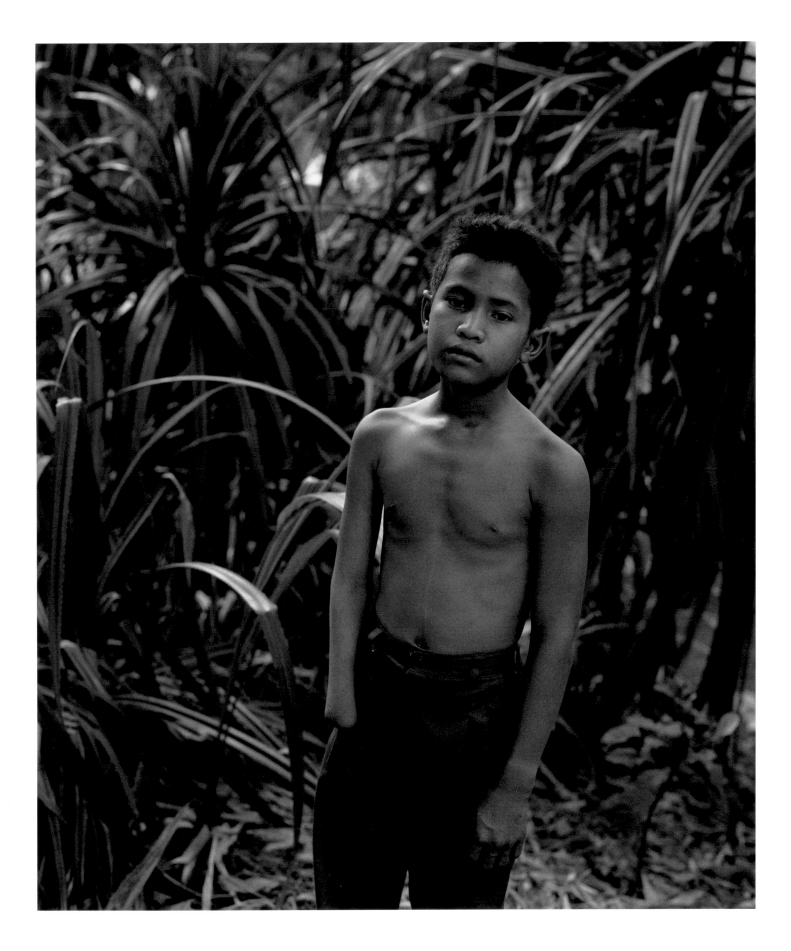

Nam Noun – I was playing with a detonator I found behind my house and it blew up. My hand was broken so badly the doctor cut it off. I want to be a football player like David Beckham but with one hand, I can't even clean my plate.

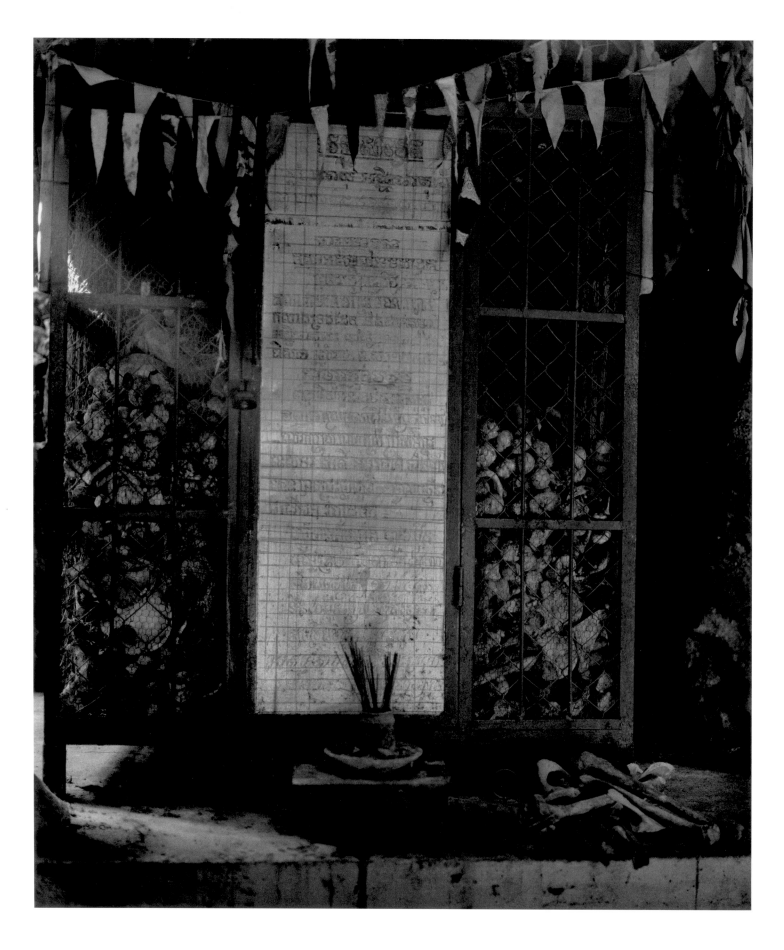

Bones and skulls of Khmer Rouge victims inside killing cave which villagers made into an altar.

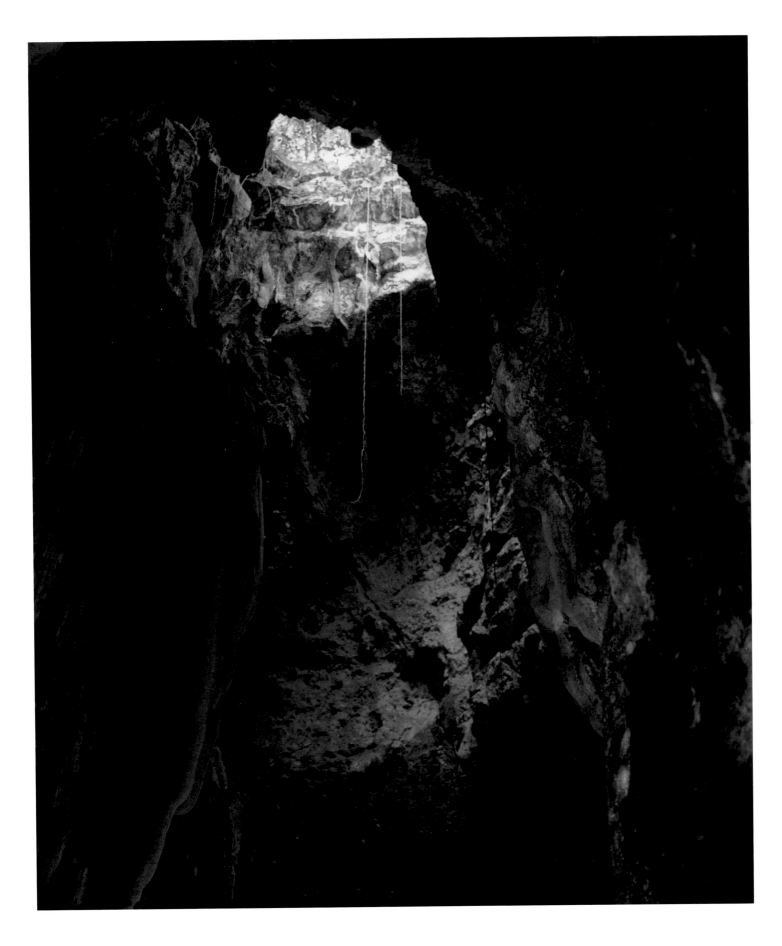

Killing cave southwest of Battambang where Khmer Rouge pushed their
victims through a hole in the roof to fall to their death.

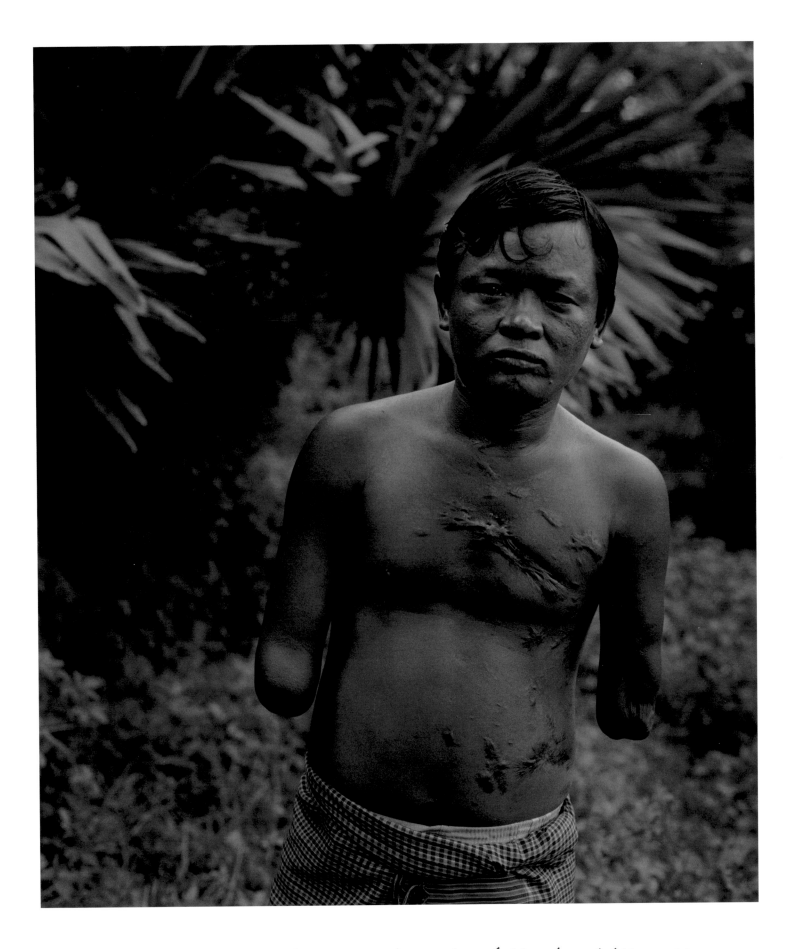

Mort Douk – I was clearing mines with only a knife when I hit a chinese mine. Both my arms were blown off. But women still like me so my godmother arranged a marriage for me. Without arms it is humiliating for me. My wife and children must help me bathe, go to the bathroom and dress. It would have been better for me to lose my legs.

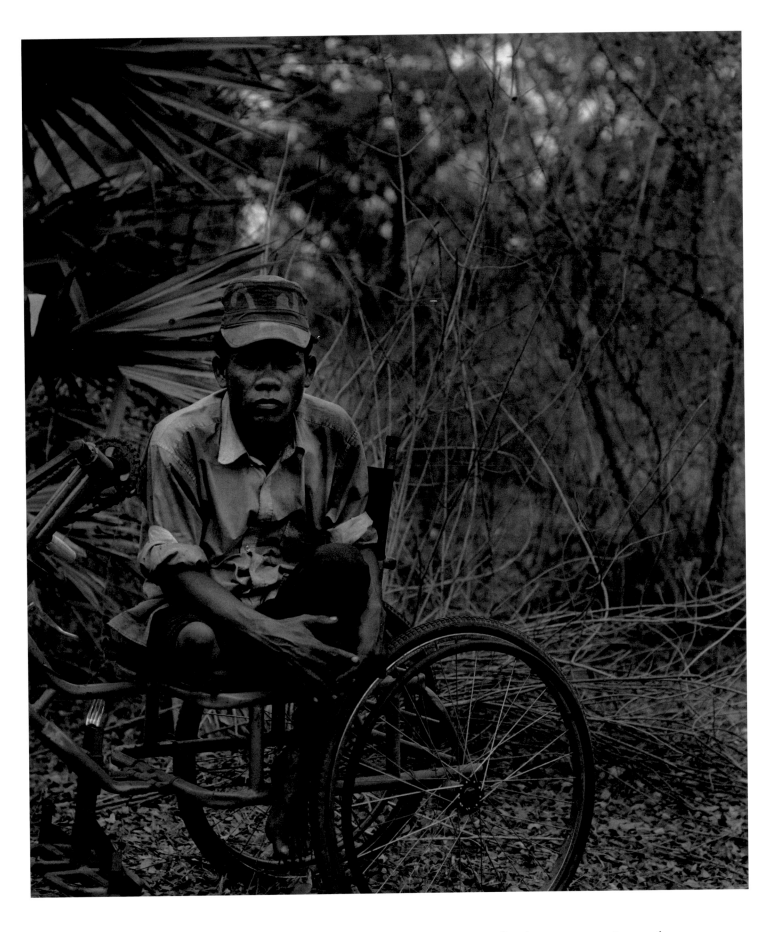

Khuon Py — Just before the Vietnamese left I was fighting for Hun Sen against the Khmer Rouge when I hit a blue Chinese mine. My wife left me after I lost my leg. She remarried and wouldn't let me see her. I saw my children though. I get around in this homemade chair because I keep falling with a fake leg.

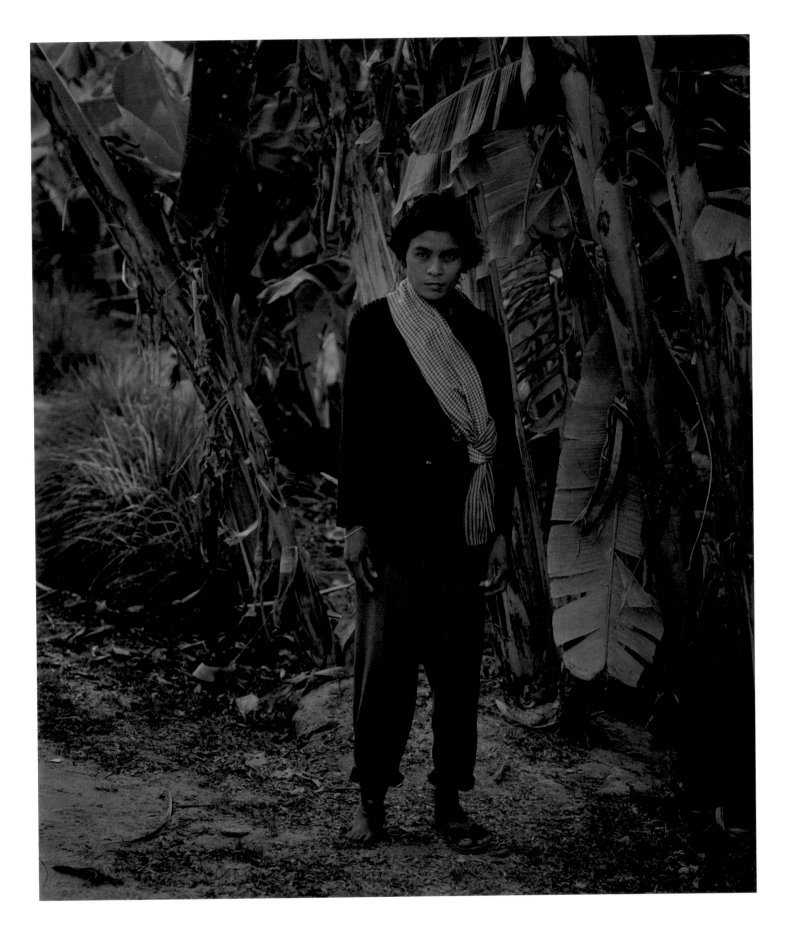

Haem Lee - For seven years I was a rice cook for the Khmer Rouge and my husband a K.R. soldier. I lost my leg while gathering firewood in 1983. When I was young I used to wear skirts. I was a "freshie". I'm shy now to show my missing leg. I miss wearing skirts.

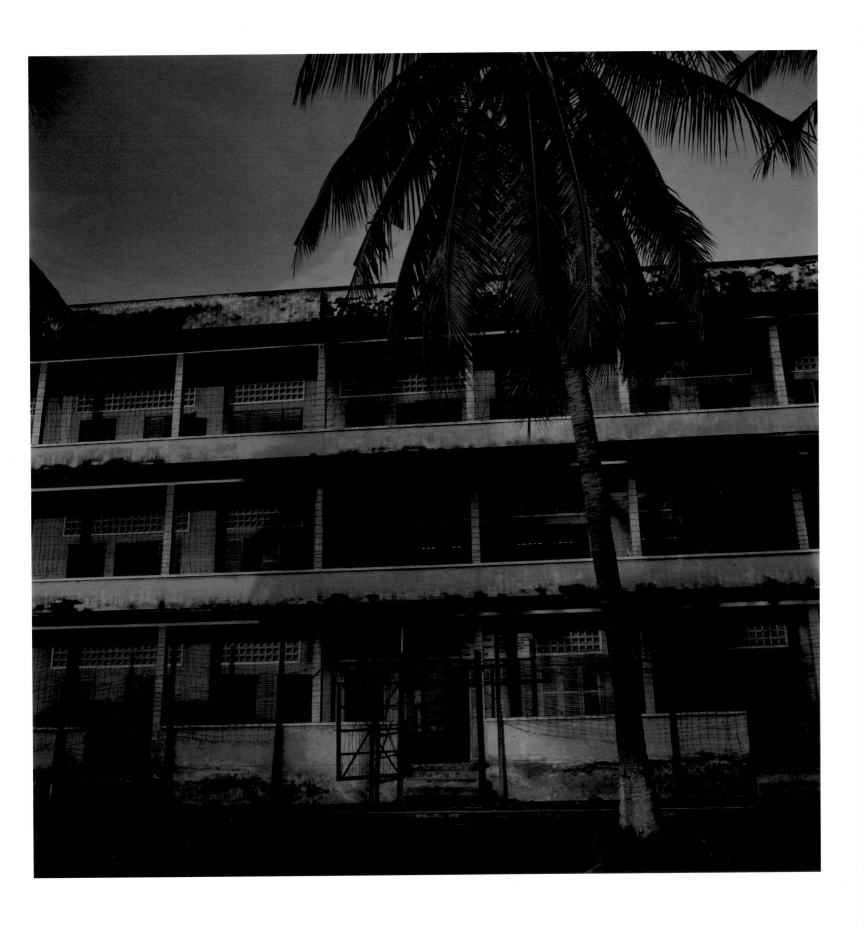

S-21 prison Phnom Penh where men, women, and children were tortured
and killed by the Khmer Rouge.

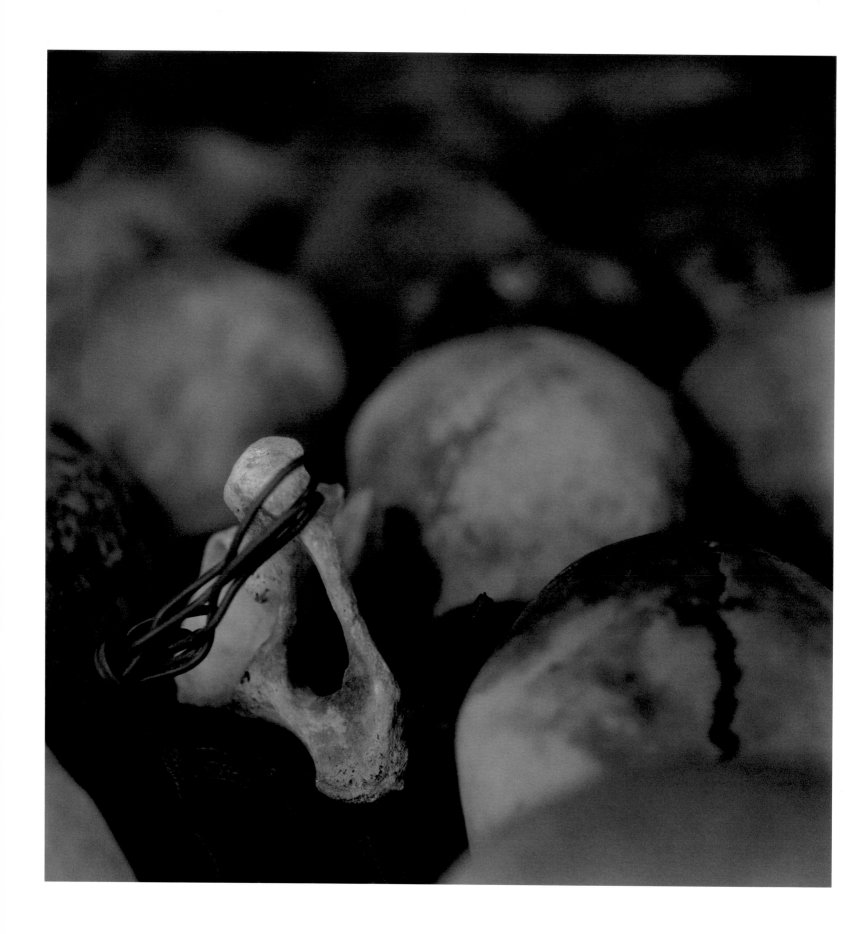

mass grave found at Choeung Ek

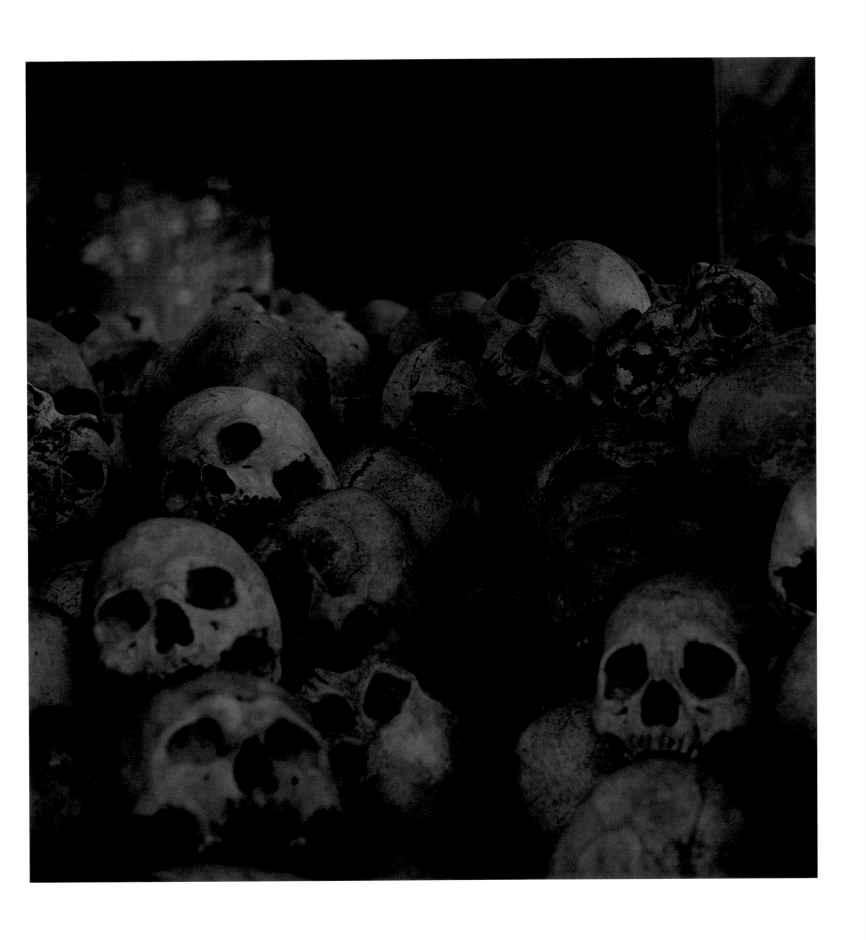

mass grave found at monastery Wat Thmei

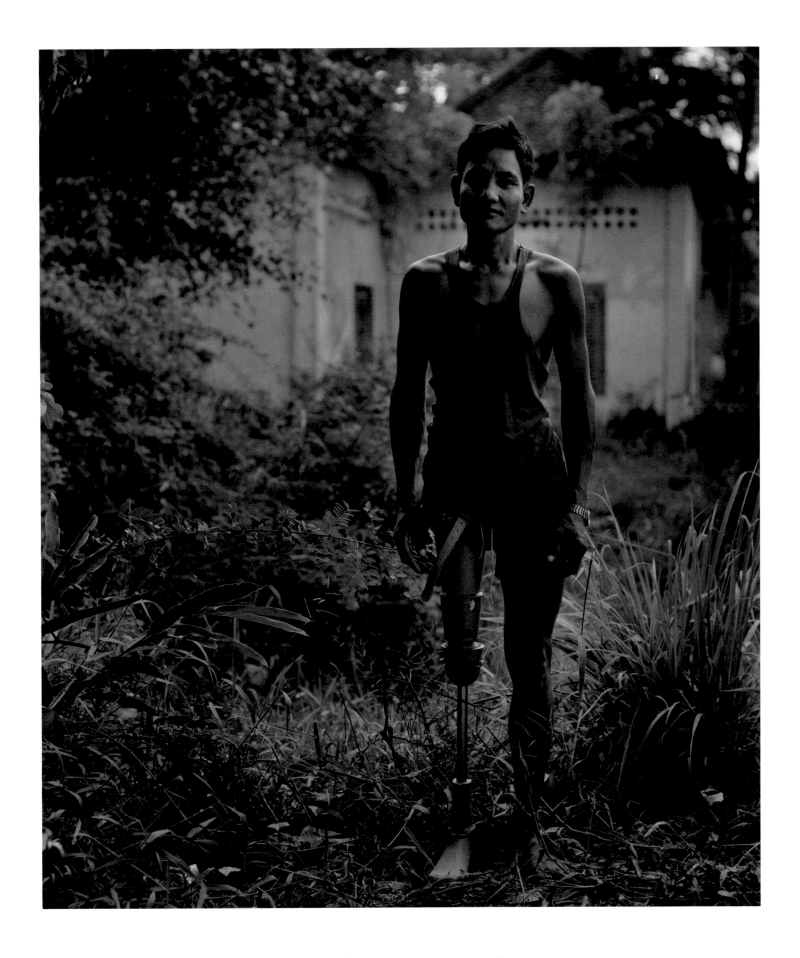

Mon Pac — It was a mine hidden in the forest that blew off my leg. I used to be a rice farmer. All my new legs break when I do heavy work. No one has enough money to make us good legs. Only God did that.

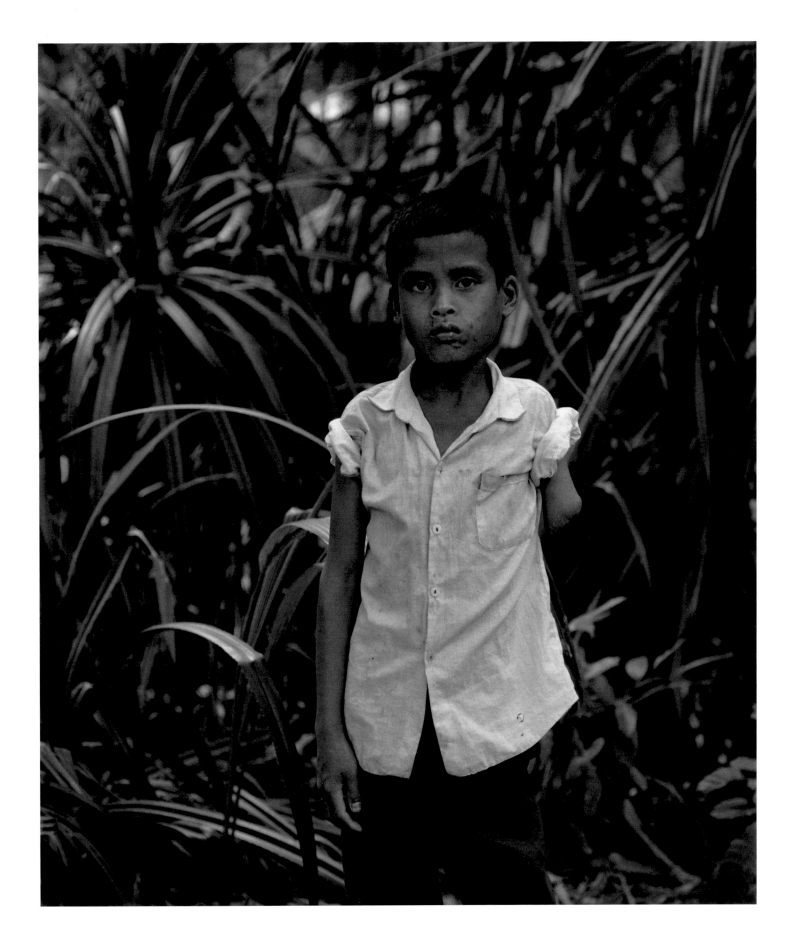

Sok Ream - Last year I was playing with a mine behind my house. I did not know what it was. My kneecap and arm were blown off. I used to be lefthanded. My bicycle riding is what I miss most.

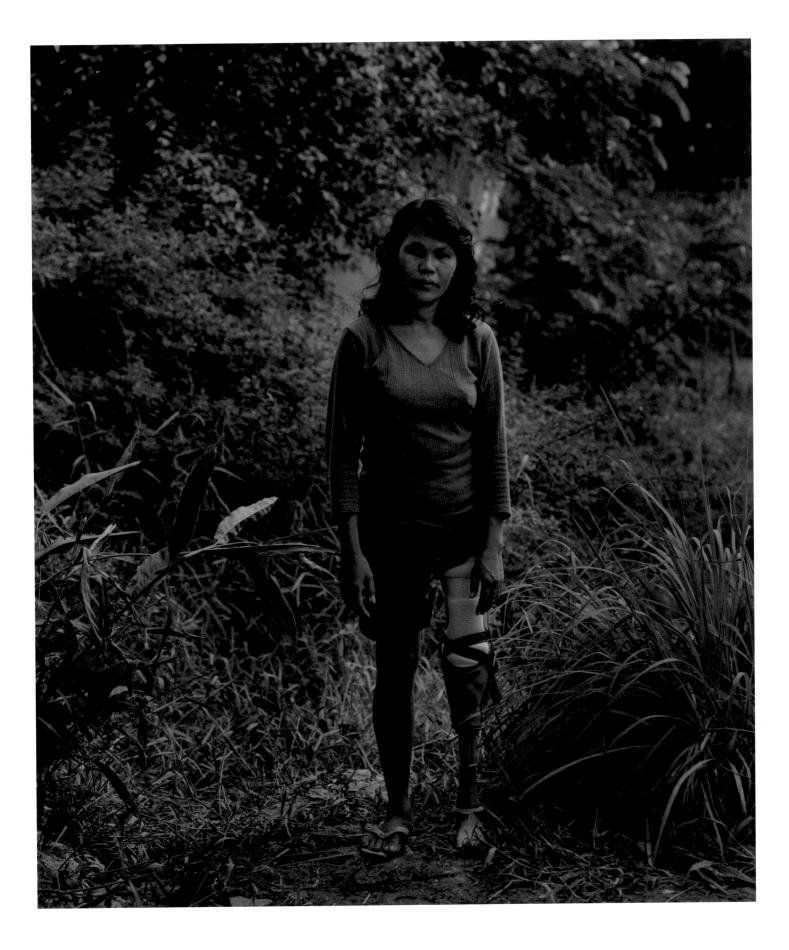

Crak Lone - While I was picking corn in Pailin I hit a mine. Many people had walked over the same place so I was just unlucky. I am a widow with five children so now I make flutes for my children to sell around the temples.

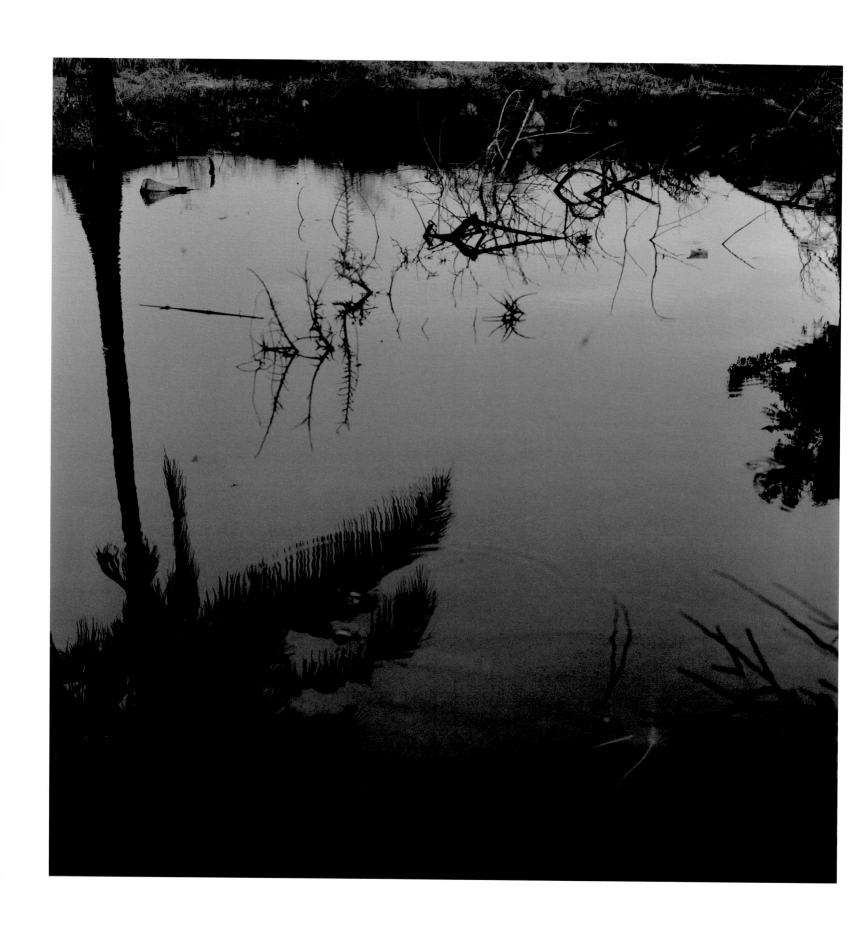

Water lily pond near Phnom Teat Broh site of mass killings and burials.

killing fields, Kampong Cham, where about 3,000 members of a commune now called "Dork Makara" were killed. The name means 10 January which is the celebration of the Vietnamese deliverance of Cambodia from the Khmer Rouge. all the members were "new people" relocated from Phnom Penh.

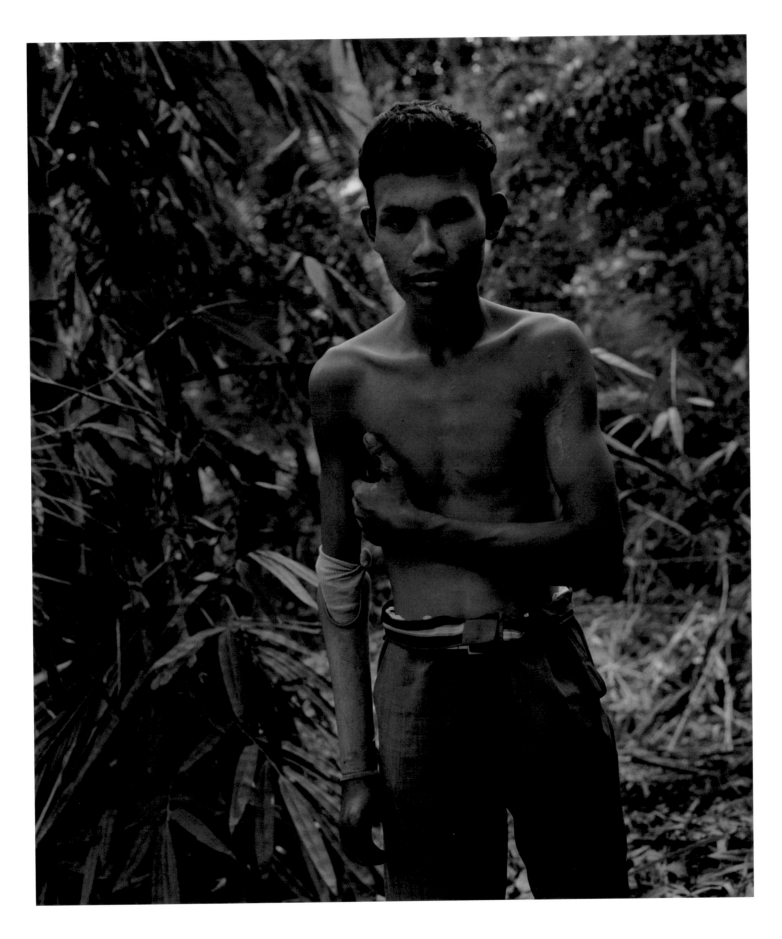

Chhem Rotha - When I was eleven a crew of villagers cleared a minefield where I live. I wanted to see if the mines worked so I threw one into an ordnance pile. I laugh now because I was so stupid. My right arm was blown off, my eye blown out and my leg and chest badly damaged. No girls will ever love me now.

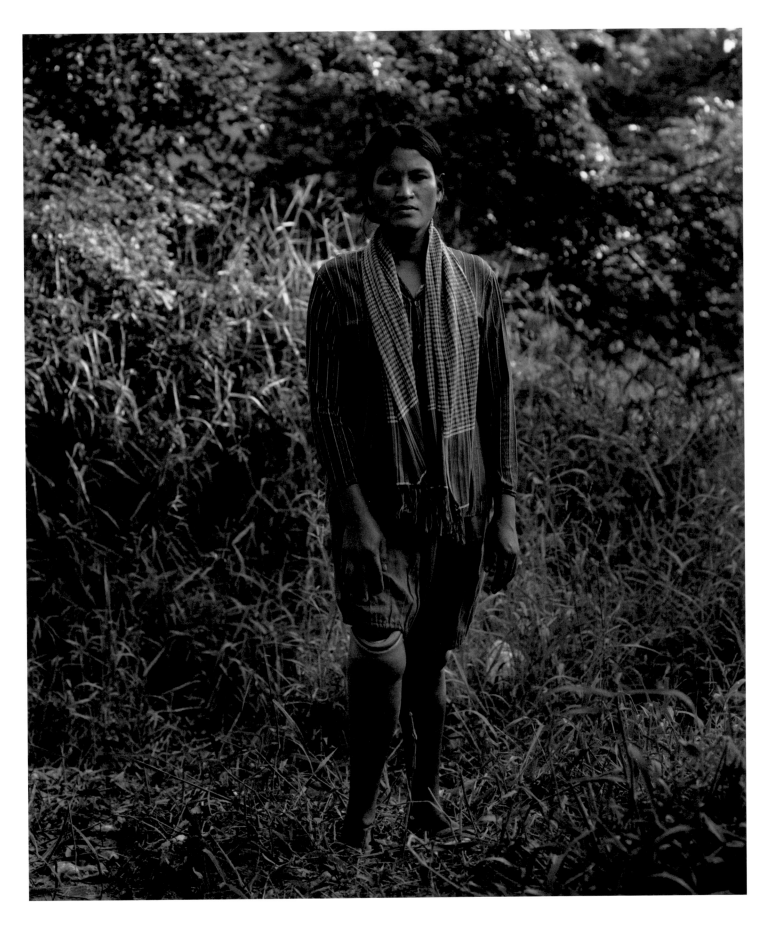

Monk Taoun - I am a widow and at 34 I am too old to be married again.
When I went behind my house to relieve myself I stepped on a mine.
Before I lost my leg I wanted to be a tailor but now I have no money.
"Do you see the sparkles on my shirt?"

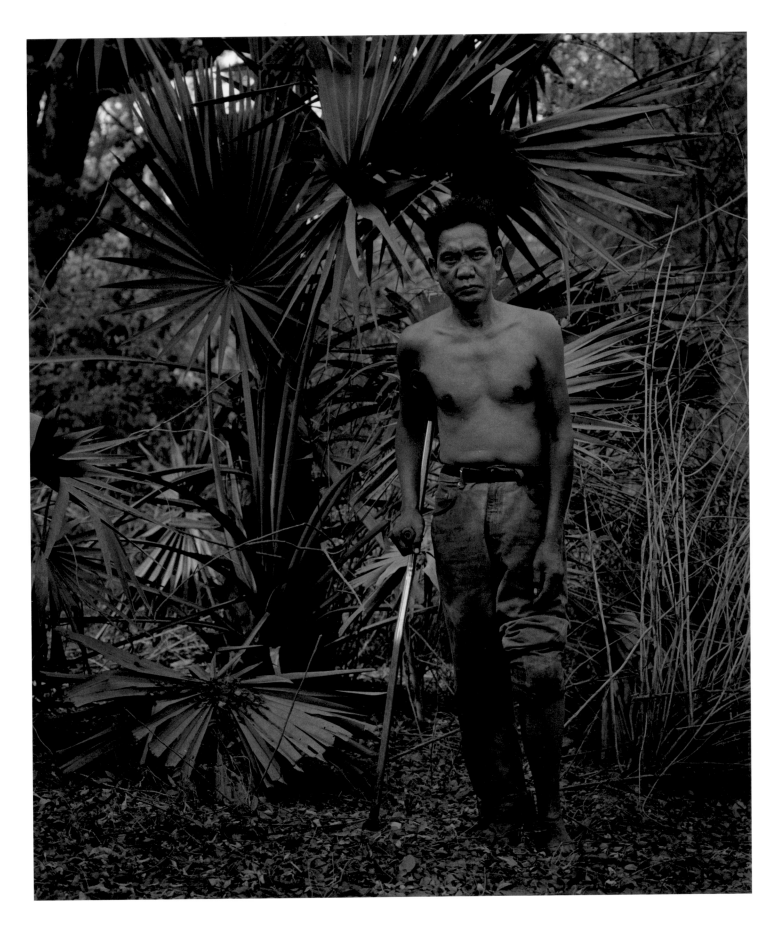

Luon Dort - I fought for Lon Nol, the Khmer Rouge, and the Hun Sen army.
When I returned home after 20 years of fighting my wife and children
had already left me. I had lost my leg to a mine and my wounds on
my face, chest and shoulder were from a rocket. I am so alone.

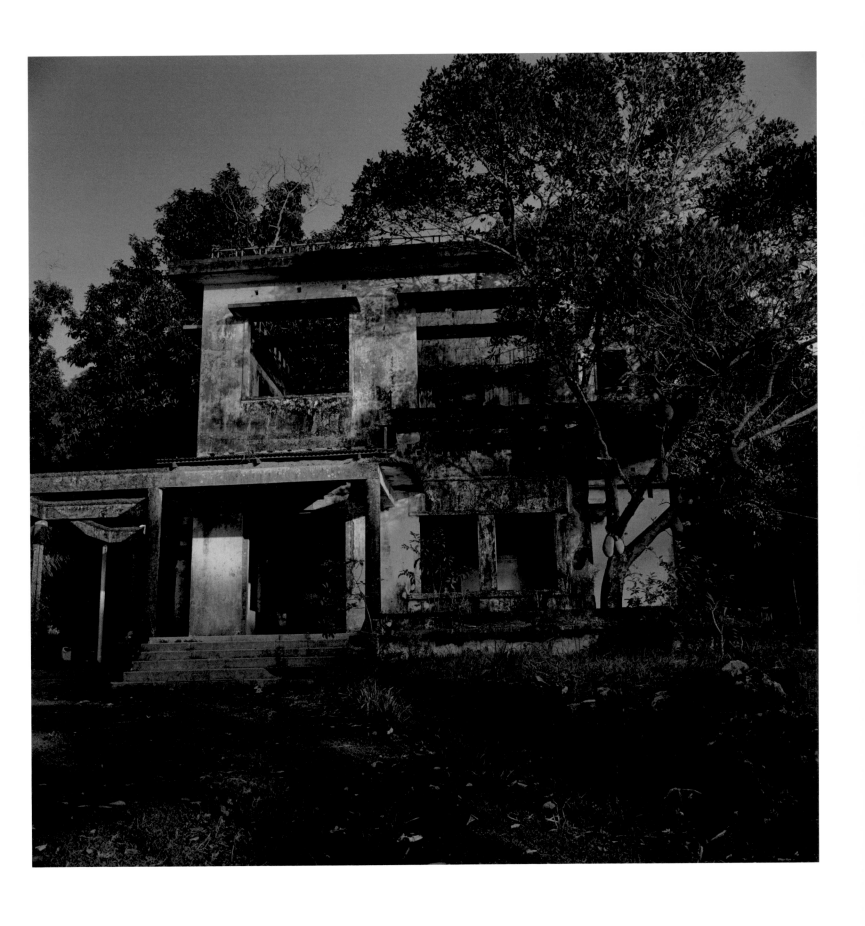

Buildings ruined from years of war exist throughout the country.
Some are occupied by squatters but others frighten the Cambodians
because of "ghosts" and so remain empty.

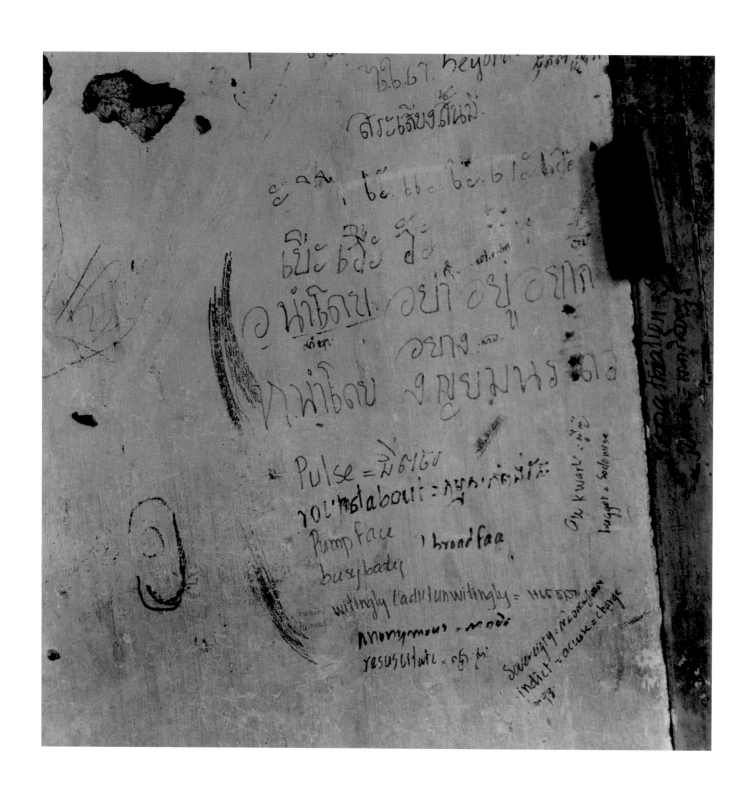

Wall inside the abandoned villa.

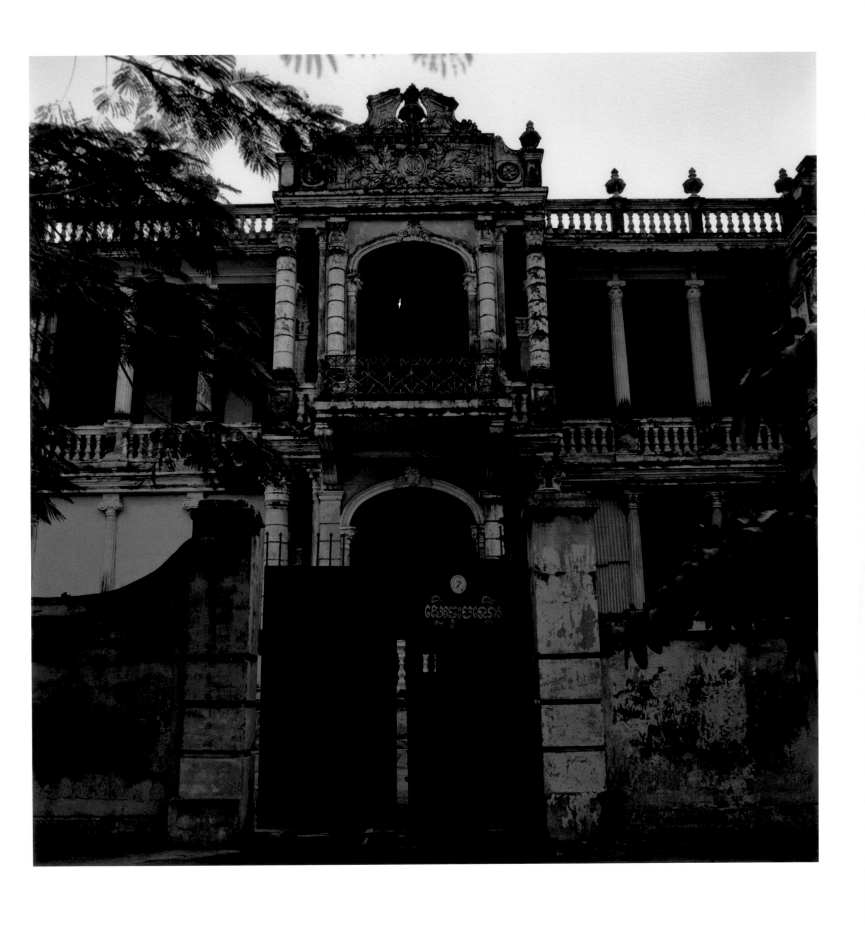

Abandoned villa in Phnom Penh now used as a police station.

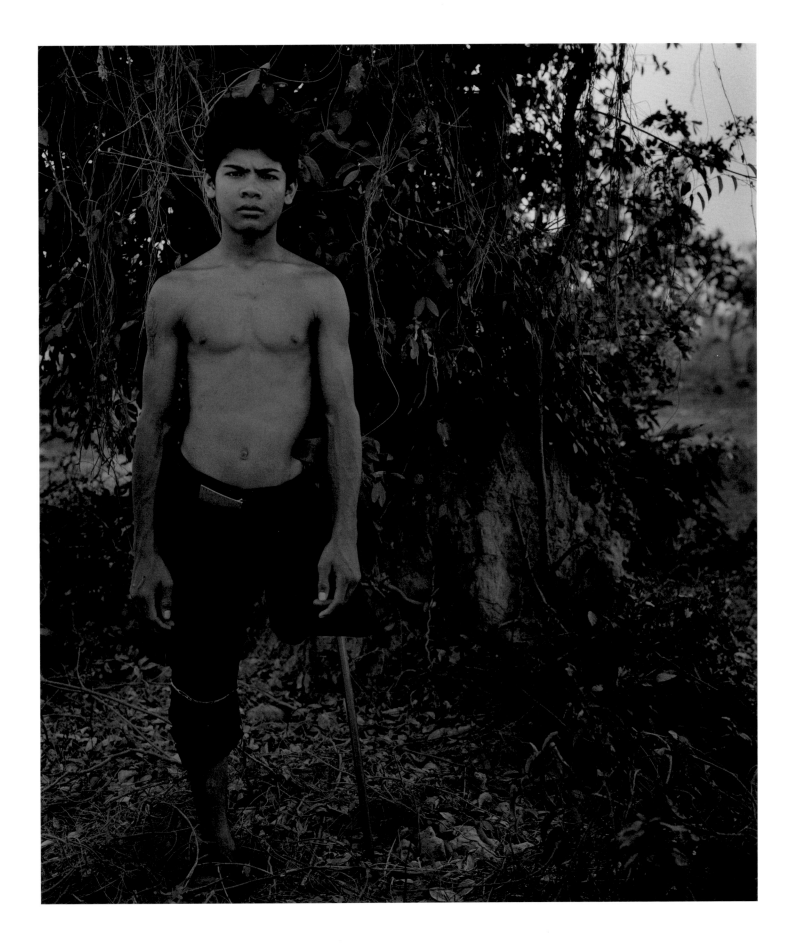

So Tol - There were five of us walking along a path. The littlest boy saw a pineapple and picked it up. It was a mine which killed the first three children, blew off my leg and blew off the arm of my sister who was behind me. I am so angry.

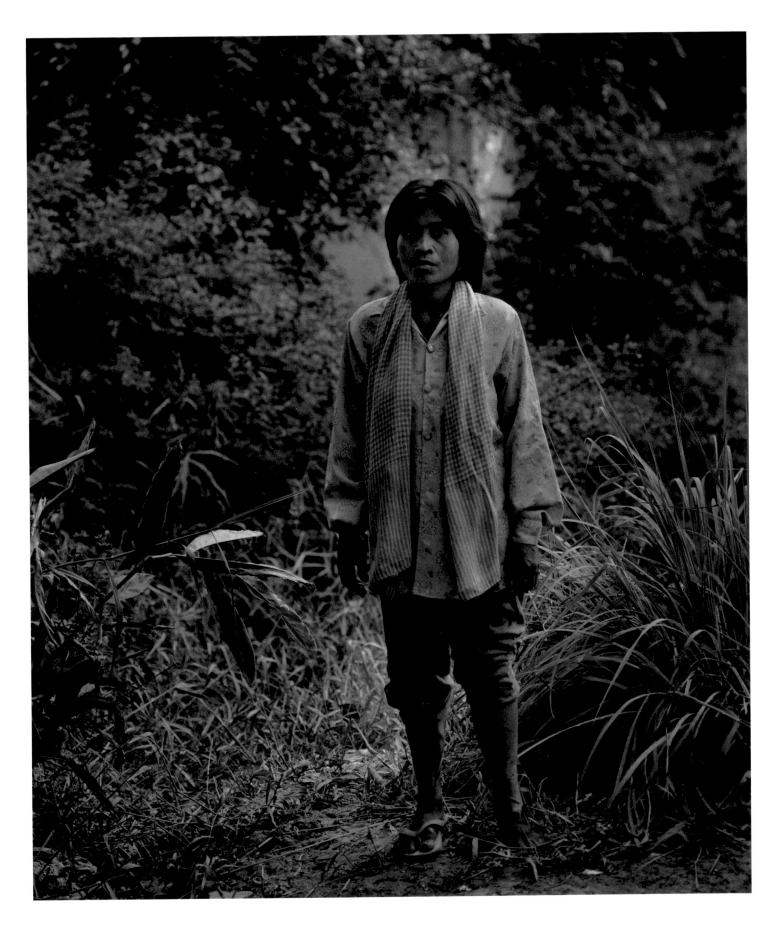

Yun Sokhun - my first husband was in a truck that hit an anti-tank mine killing everyone but him. When he died later I remarried. Then I lost my leg on my way to the rice field. We are very poor so most women do not go to school, like my daughter who is home helping me. I have one child in school but I wish they all could go.

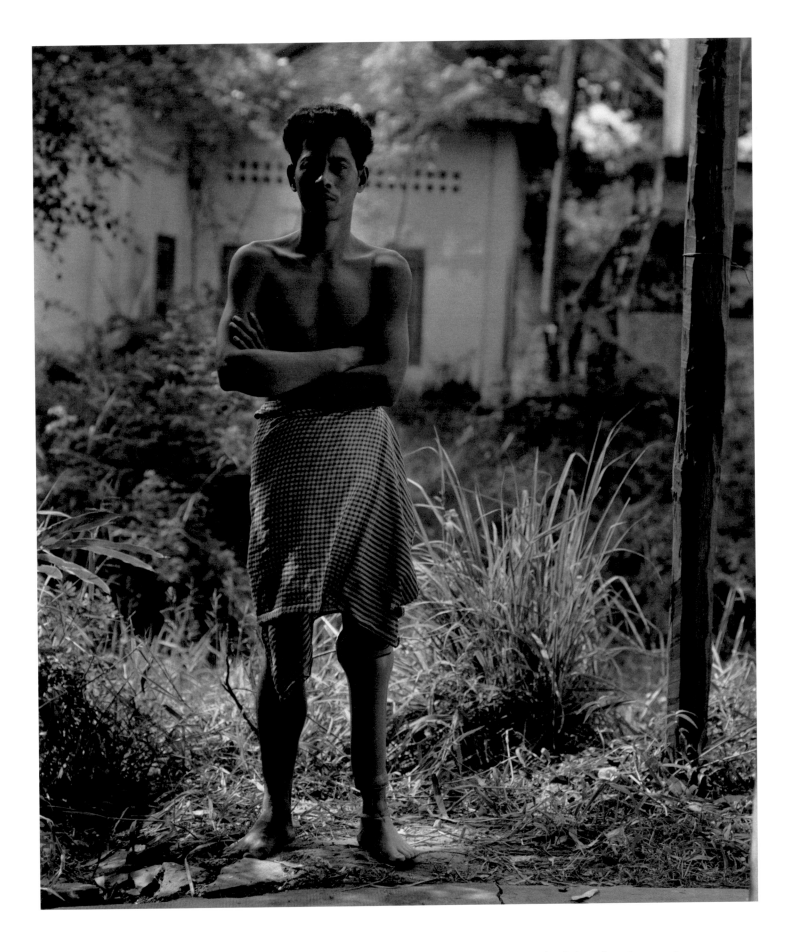

Ma Saq - In a big battle against a Pol Pot stronghold I stepped on
a mine. I have no work so I just stay around the house. I have
nothing to contribute.

Mined jungle in Kampot.

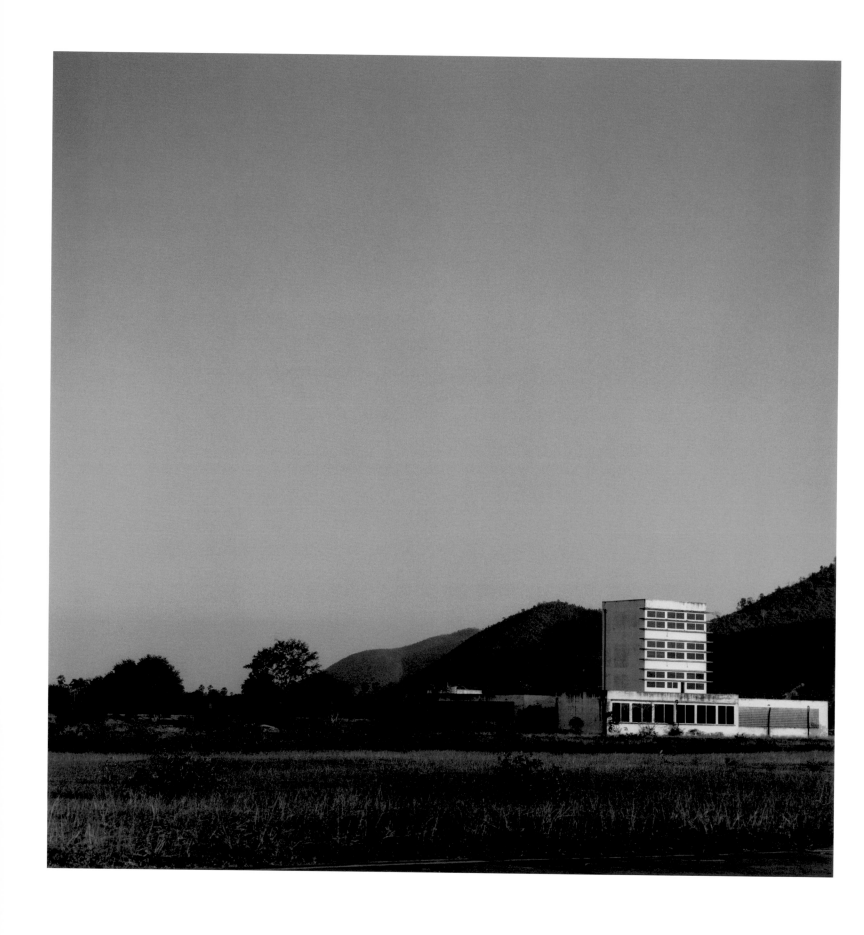

Khmer Rouge airfield where, upon its completion, workers were said to have all been killed in order for airfield to remain a secret.

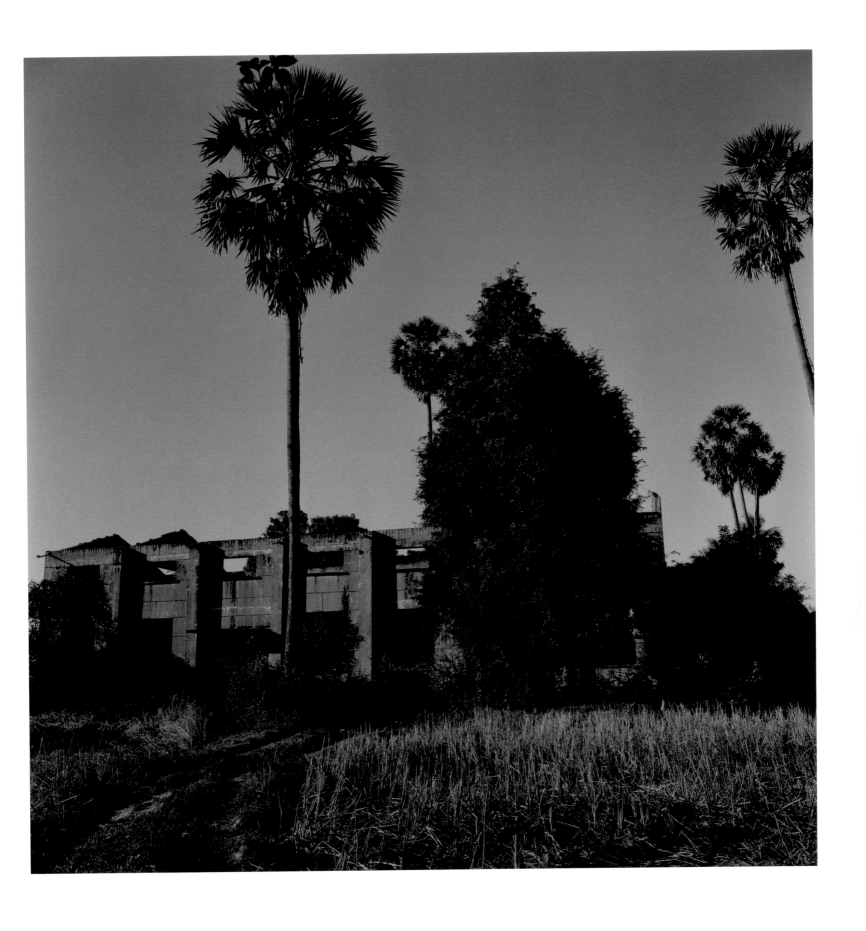

Dormitory for Khmer Rouge workers building secret airfield. Villagers will not go near it as they believe it is still haunted by those who were killed there.

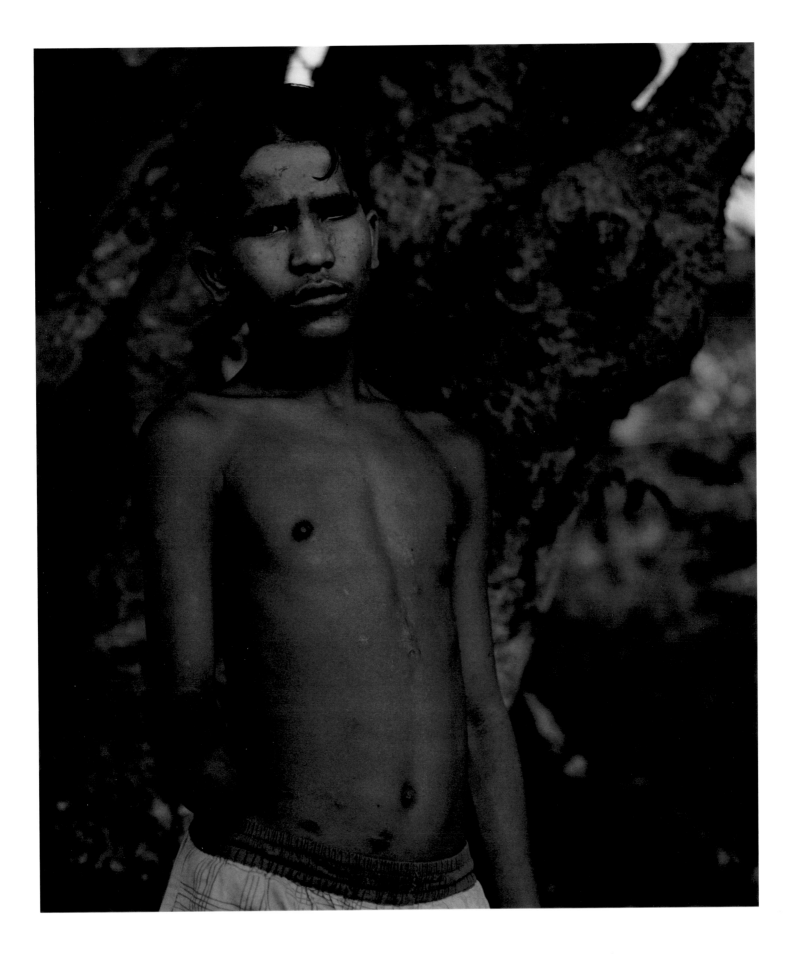

Pat Poi - When I was ten I was playing with a mine and hit it with a rock. I lost my arm and have shrapnel in my eye. This is not good because I love soccer. People look down on me. It makes me very sad.

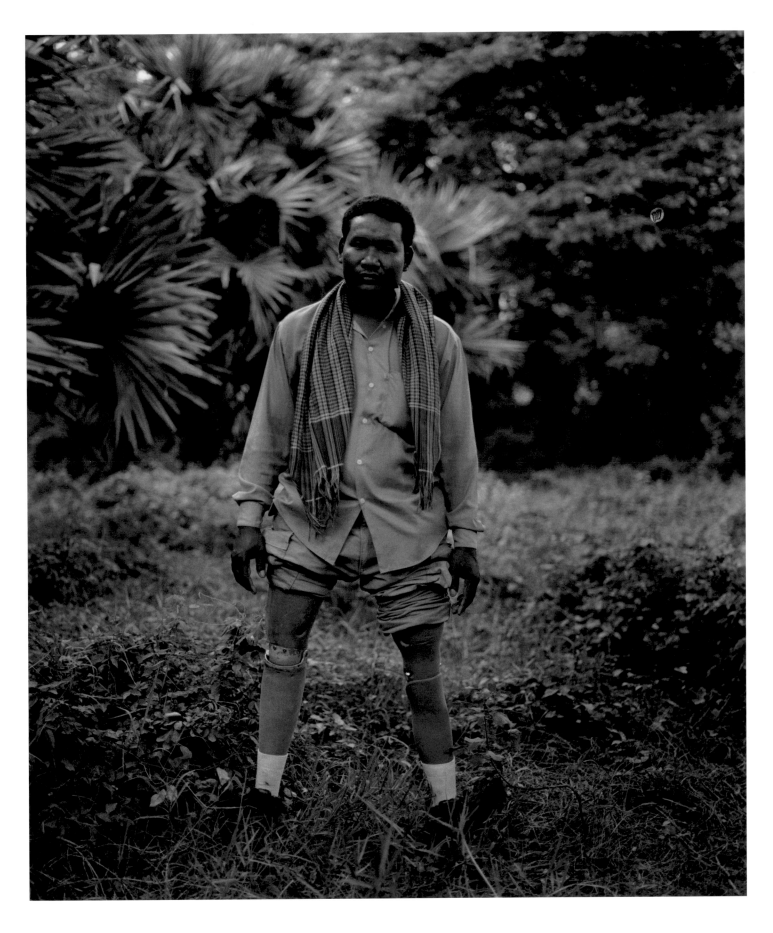

Sem Sovantha - Everyone discriminates against the disabled so it's impossible to find a job. I want to work not beg. However, the money that came from begging I used to learn English. I had three children before I lost my leg to a K.R. mine and three after. My life's commitment is to have an eco farm.

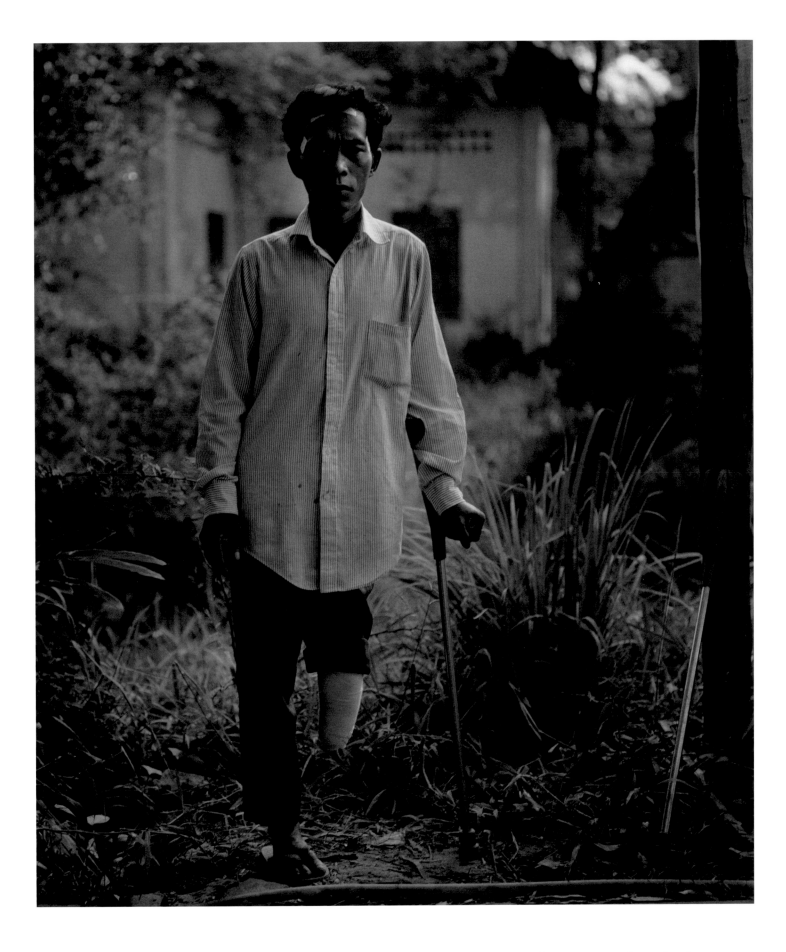

Chum San - My children were with me in the forest in 1990 when I stepped on a mine. They screamed and cried but somehow they carried me 6 km to the hospital. It is not something your children should suffer.

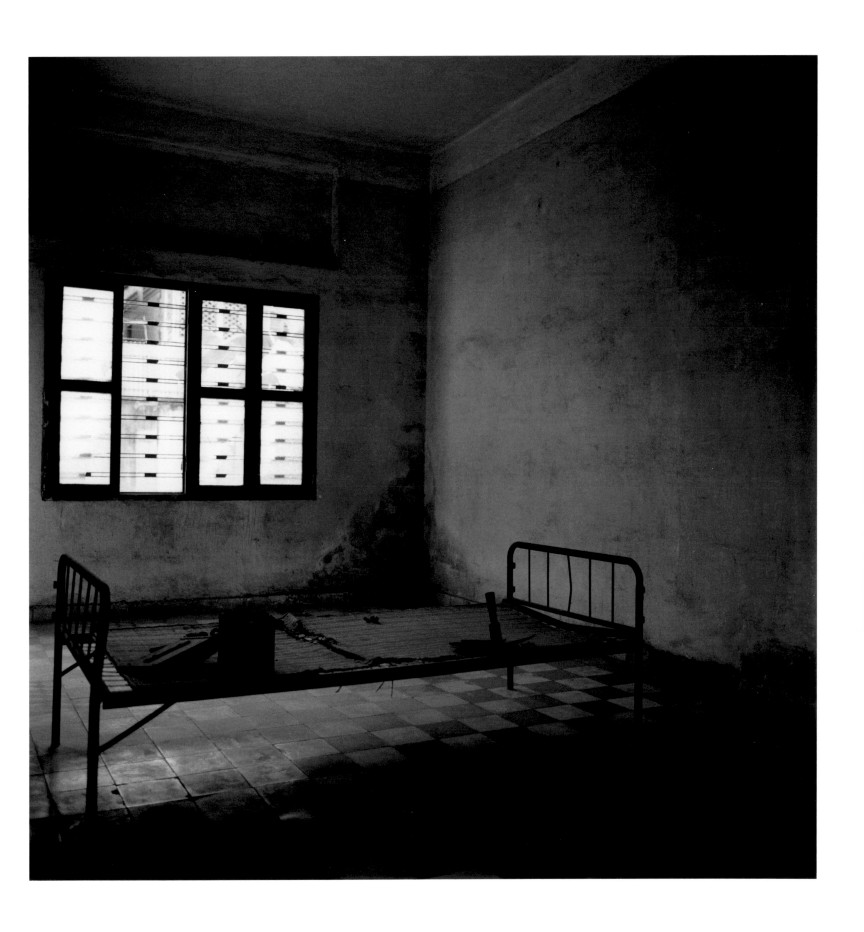

Torture room inside S-21 prison

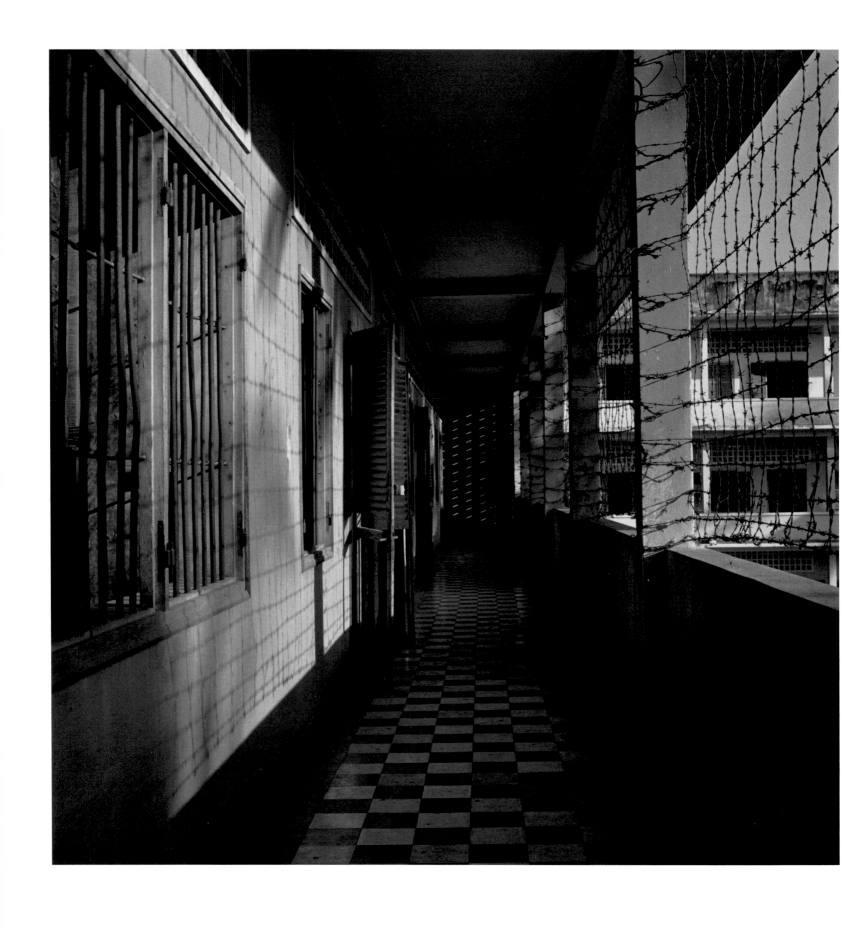

S-21 prison upstairs hallways were fenced with barbed wire so prisoners could not throw themselves off.

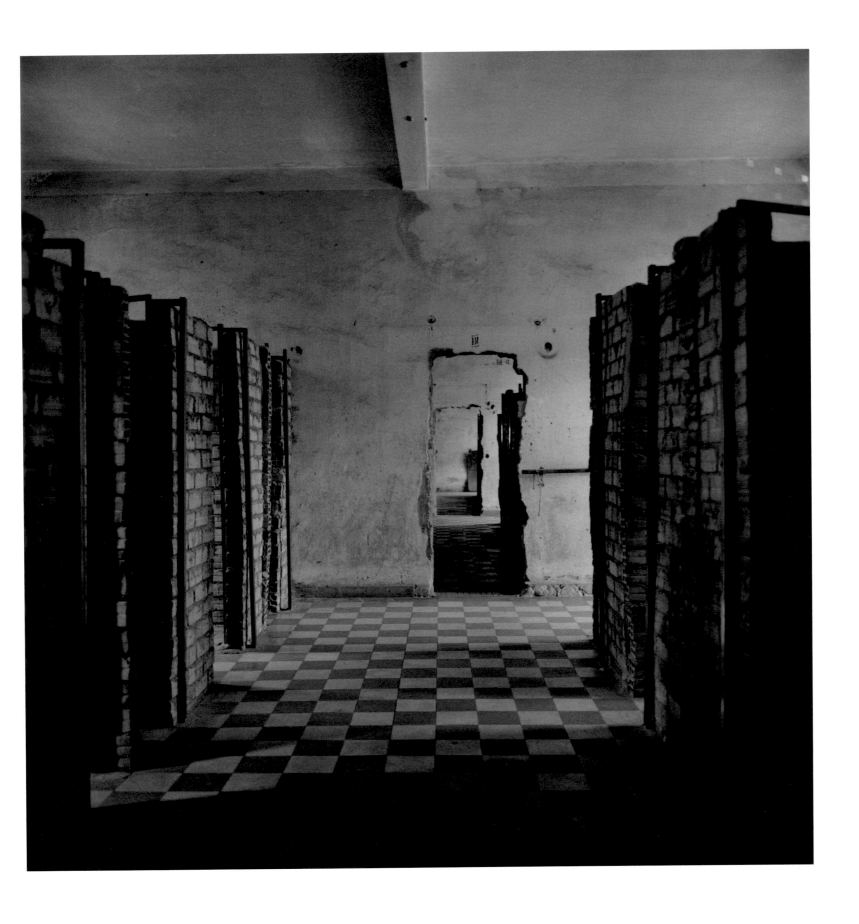

S-21 prison north wing cells about three by six feet each. Holes were hammered in the walls between rooms so Khmer Rouge guards could pass easily along rows of cells.

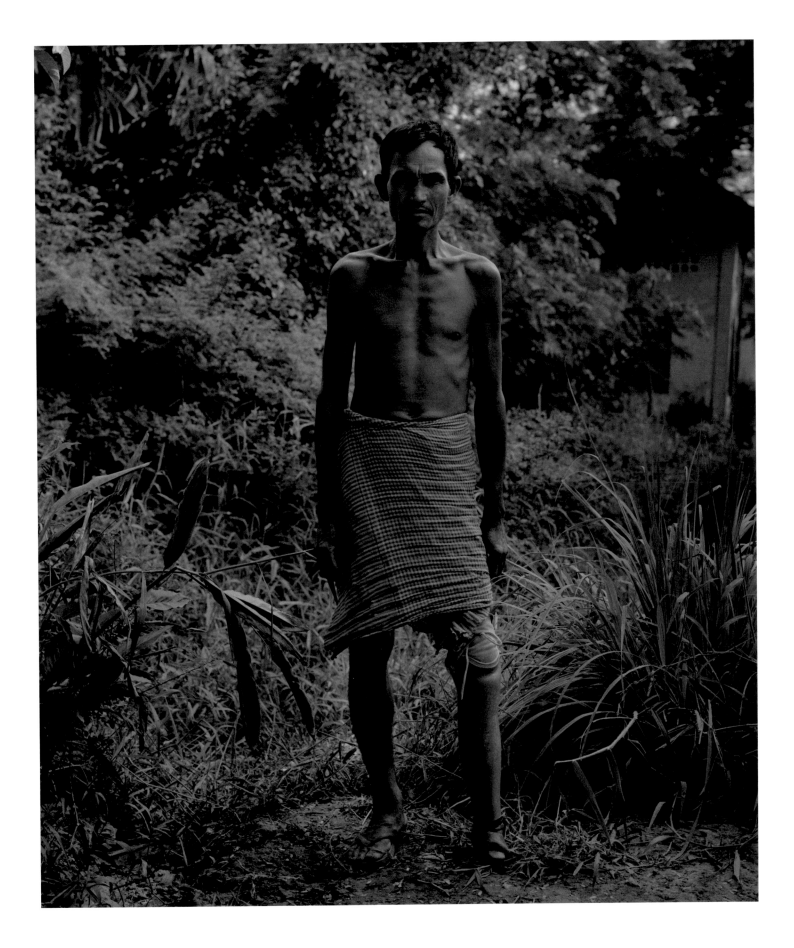

Say Sieng - My wife was very upset when I lost my leg. When I volunteered for Hun Sen's army we had six children. Since then we have had three more. Even though I have only one leg I still play with my children and plant rice. All mines should be banned.

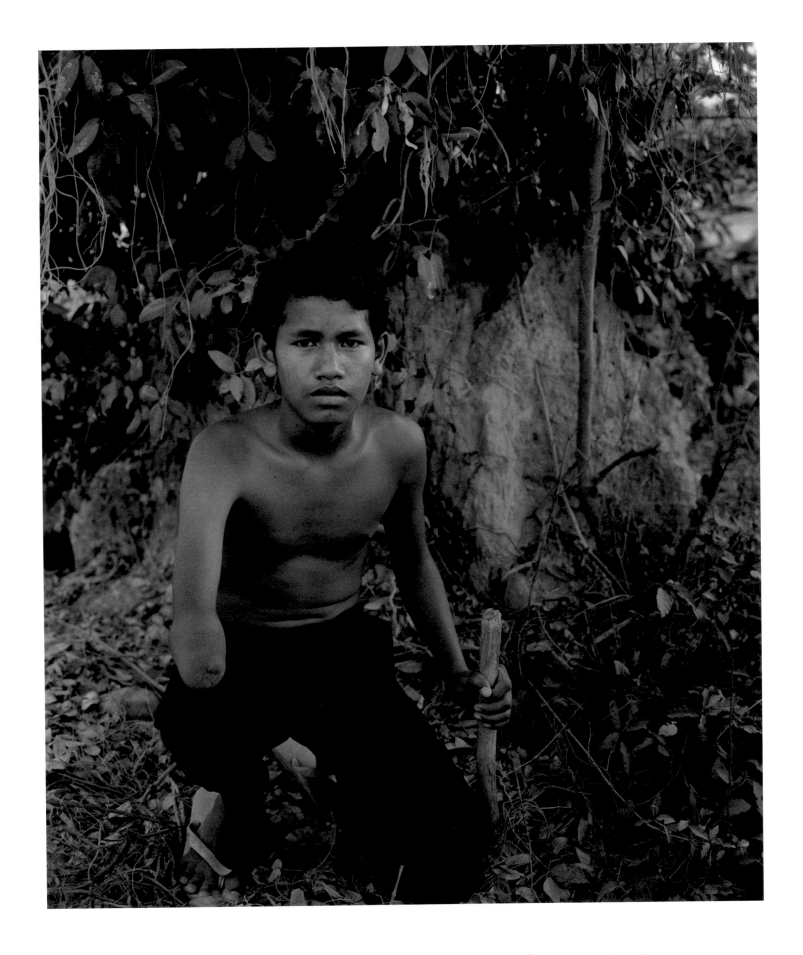

Ara Thon – no one teaches us about landmines in school. When I was eight I lost my arm playing with a mine. It is difficult to study because I cannot hold my schoolbooks while writing.

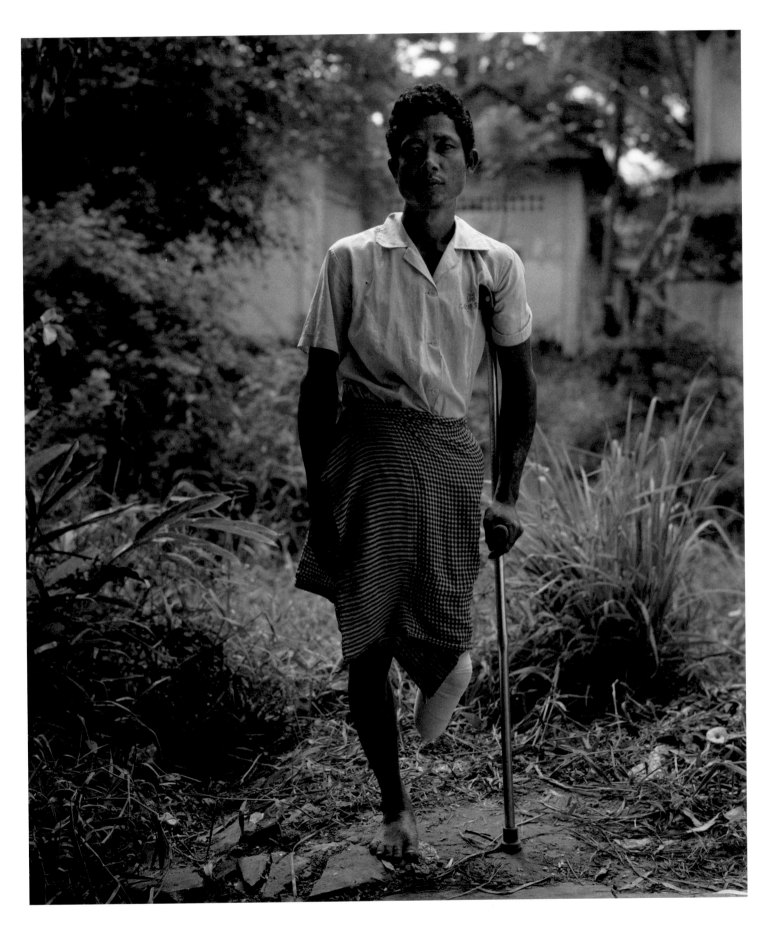

Saag Muet - While clearing trees for my rice farm in 1987 I lost my leg to a mine. I am still a farmer but because work is so slow there is sometimes not enough food for my nine children. My first leg was made from bamboo and the second one from a shell casing. Even though my leg is not there it still hurts very much.

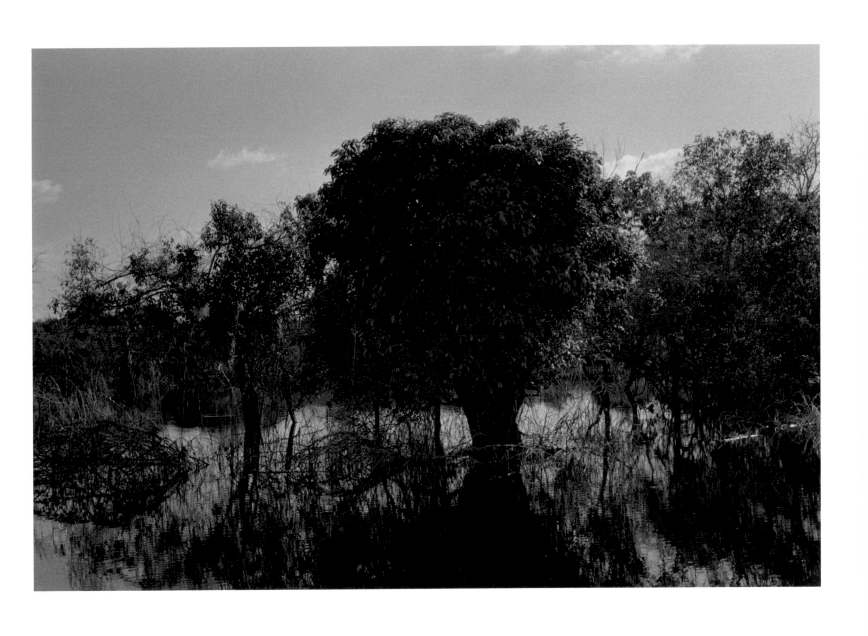

Sangker River - mines planted along the rivers maim and kill Cambodians
fishing or washing. Boatmen diving into the water to untangle reeds
from the propellers are also at risk.

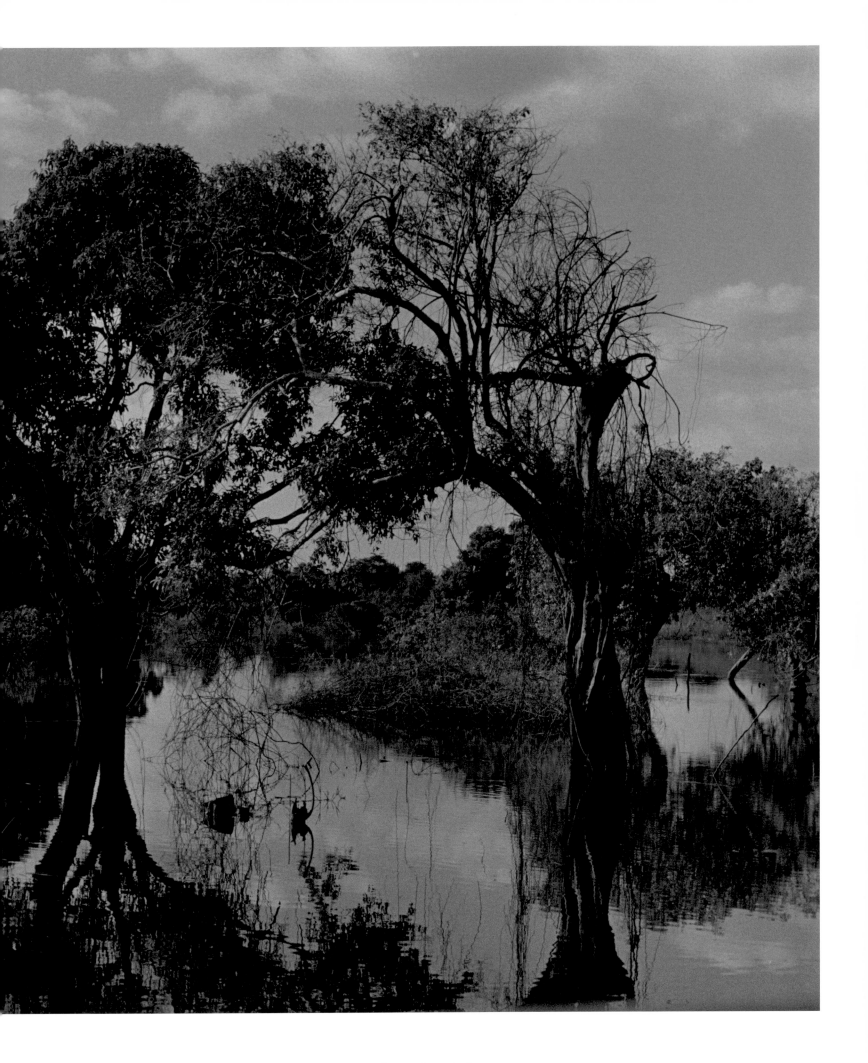

Sangker River

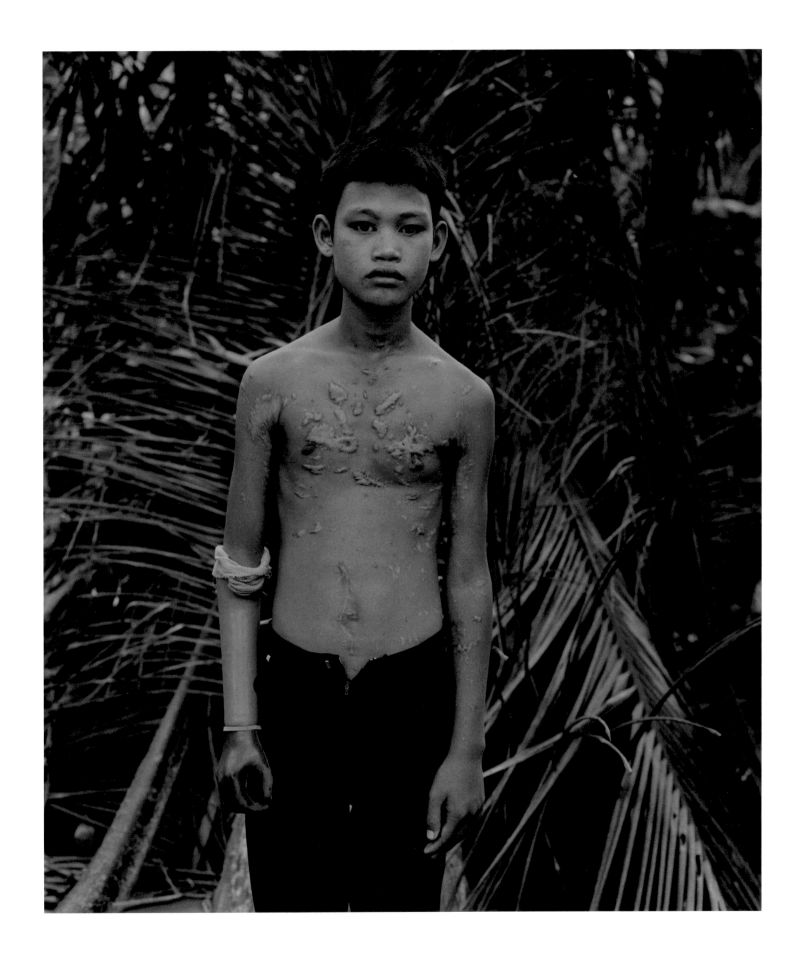

Chear Ponlot – I just wanted to catch fish for my family to eat. So I tried to use a detonator on a watermine to stun the fish. my right arm was blown off and my chest and left leg badly damaged. I don't know what my life will be now.

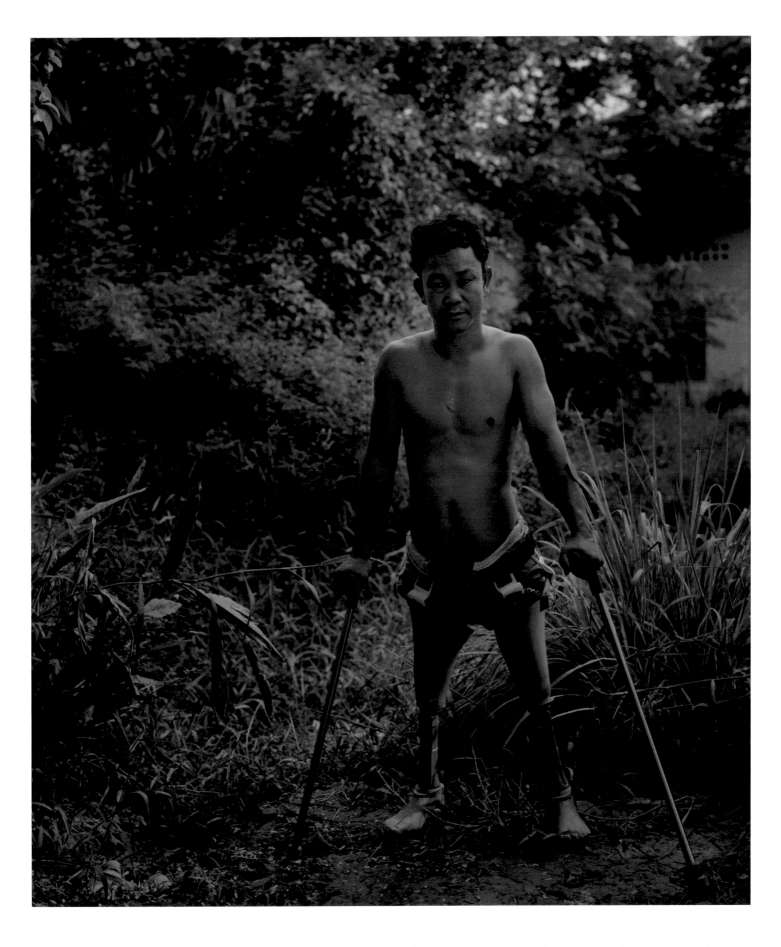

Teng Dara – I was twenty three when I hit a tripwire, lost my legs and had my insides and eye ripped up. The plastic legs given to me are too short but that's all they had. I try to sell books in the market instead of begging but it's almost impossible. There are so many other legless men.

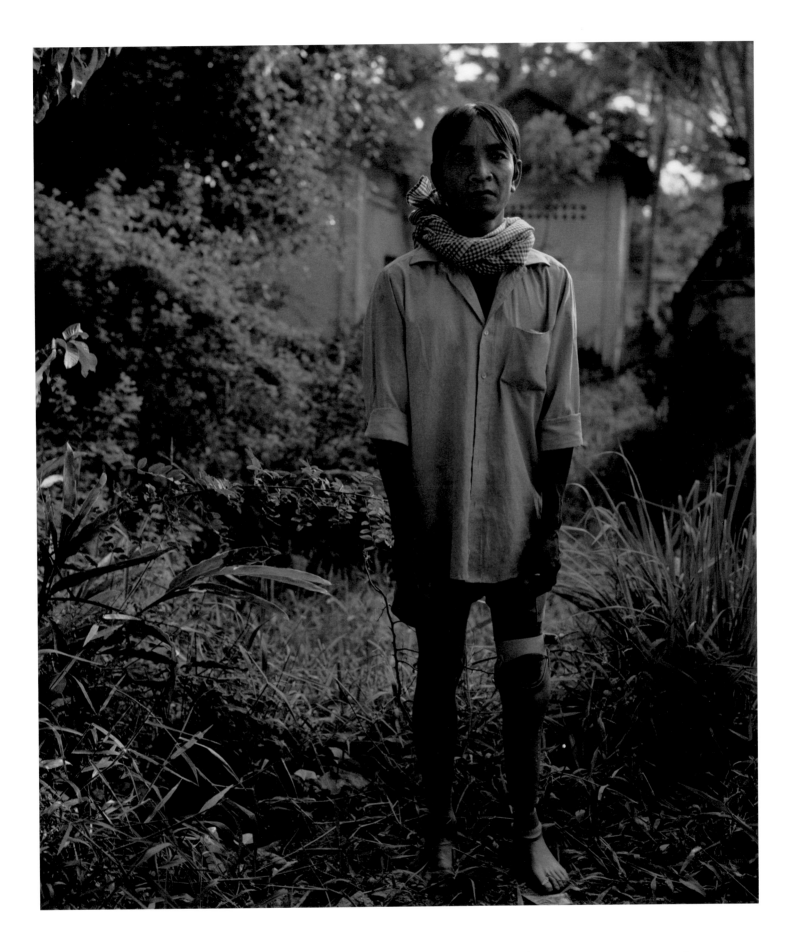

Quan Kiem - When I was a Cambodian army soldier in 1982 I lost my leg
to a mine. I was twenty five. Without a leg I feel like a baby not a man.
I dream of having a real leg. I am still afraid to walk anywhere.

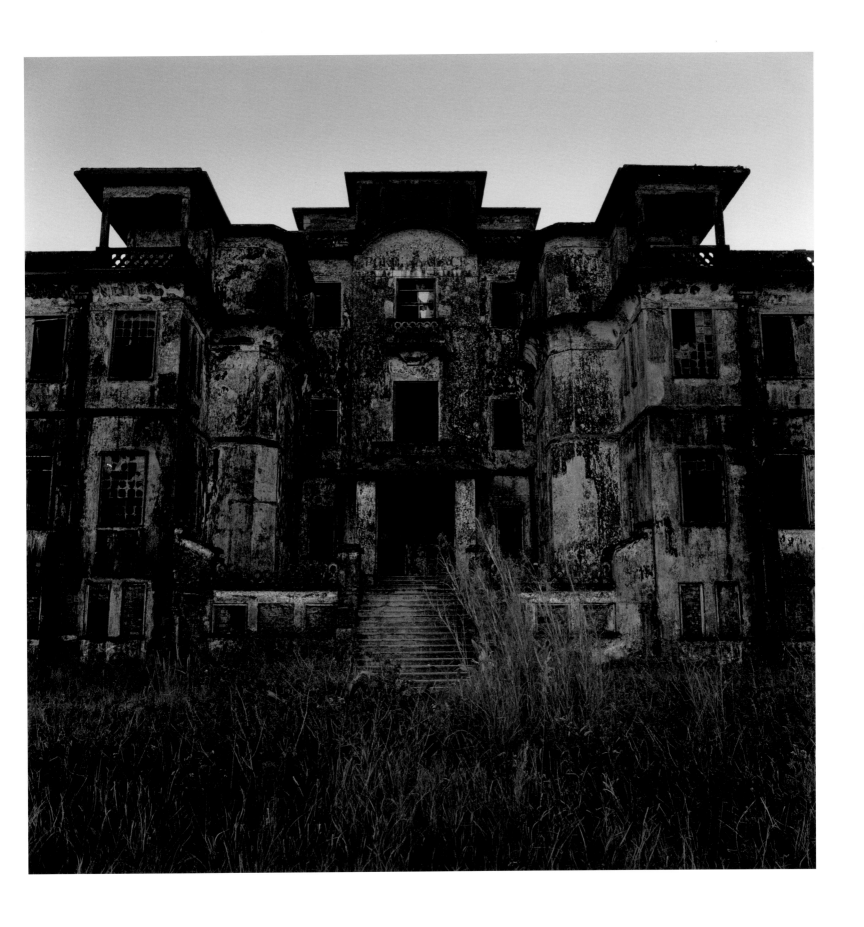

The Bokor Hill Palace Hotel was finished by the French in 1925. Because of its strategic importance the hill station was frequently fought over by the French and Khmer Issarak in the late 1940s, the Lon Nol army and Khmer Rouge in the 1970s, and in the 1980s the Vietnamese and Khmer Rouge.

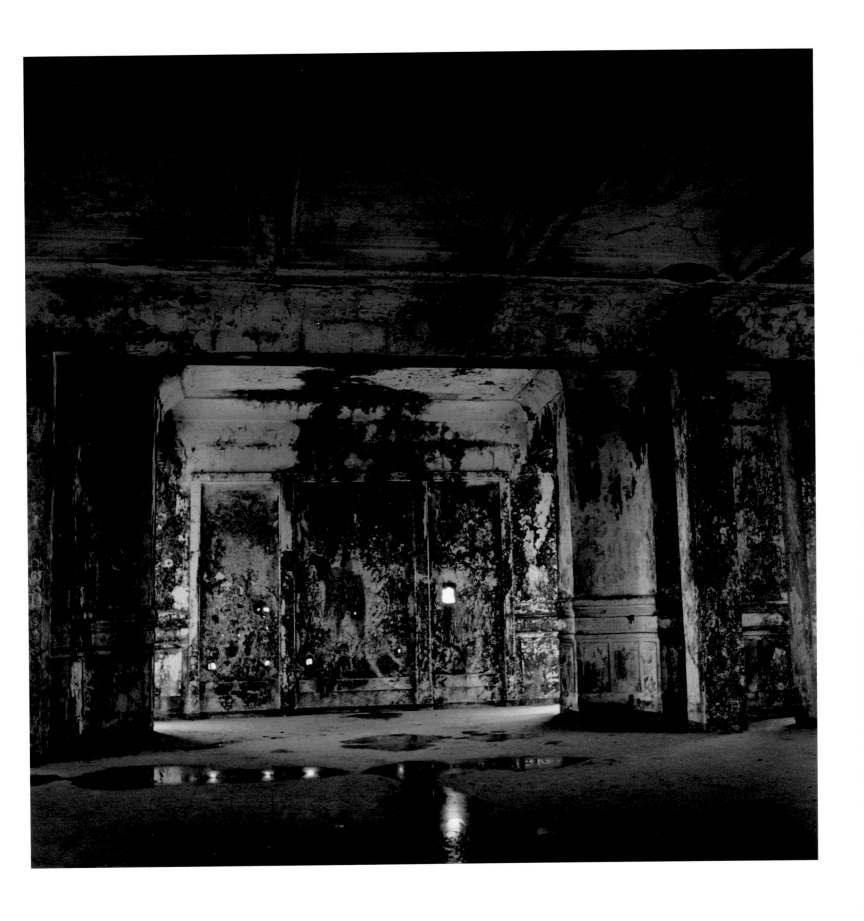

Casino ballroom in the Palace Hotel. Running parallel to the hotel road is NH3 known as the "Bloodiest Highway", Kampot to Phnom Penh, which was dangerous Khmer Rouge territory until the late 1990s.

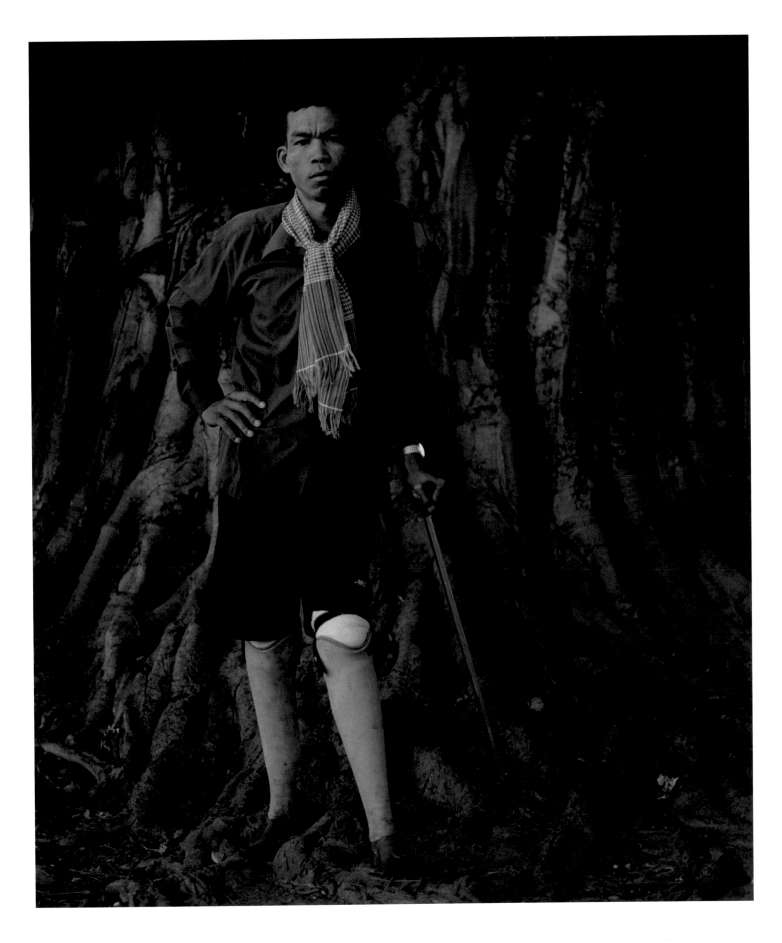

chom Sakon - While fighting for Hun Sen in 1986 I stepped on a Soviet made plastic mine during a retreat. Both my legs were blown off. My wife and I have seven children. Sometimes we don't have enough money to send them to school or even enough money to feed them.

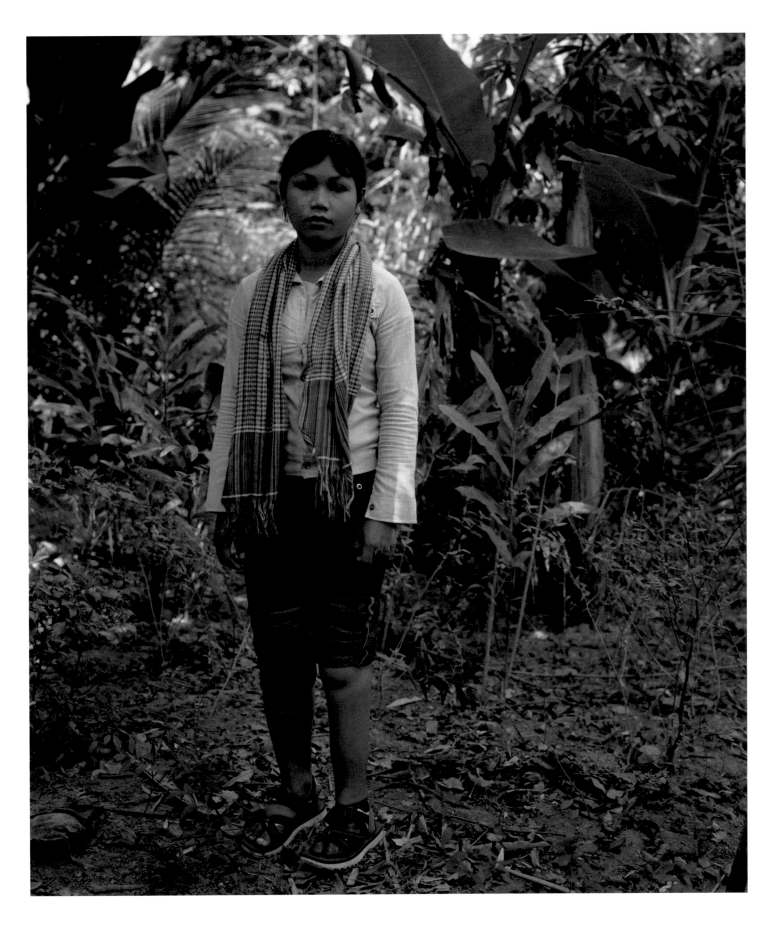

Voen Sary - my father was in the hospital injured by a mine. I was carrying my baby brother on the way to visit him when I stepped on a mine. My little brother was hurt and I lost my leg. Two months later my mother died. It is difficult for me to gather the harvest and support my sisters and brothers. I don't know if I ever want to marry. I want to be a doctor.

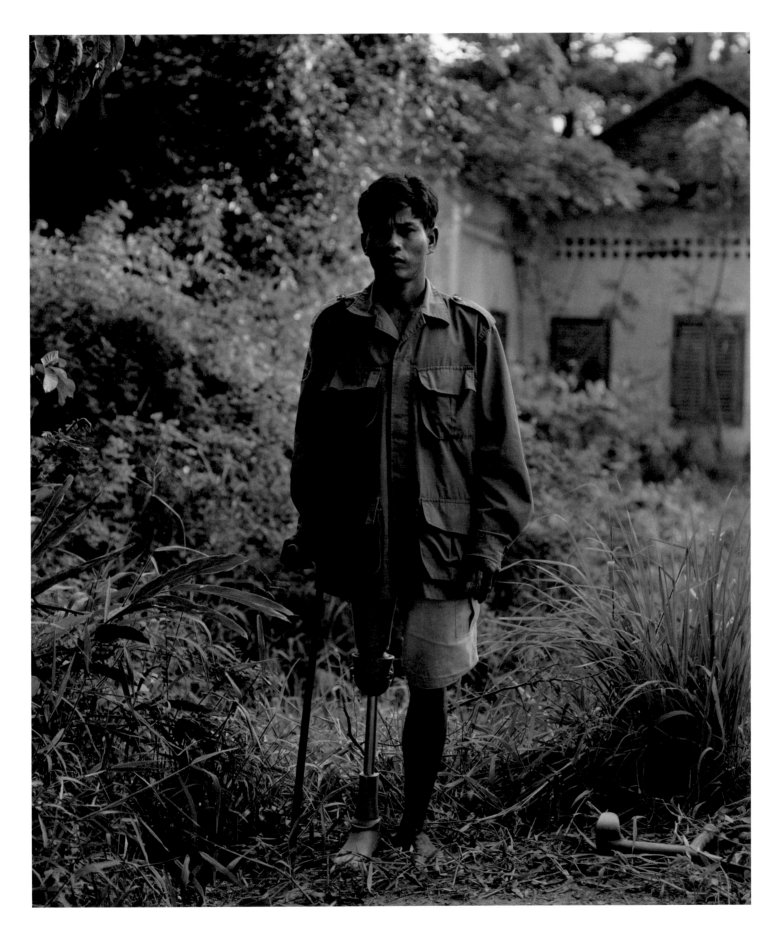

Rem Rouen – When I was clearing a beanfield near Toule Sap I hit a landmine. So without a leg I cannot work very well. Life is full of hardship for my wife and three children but what we miss the most is taking our walks together.

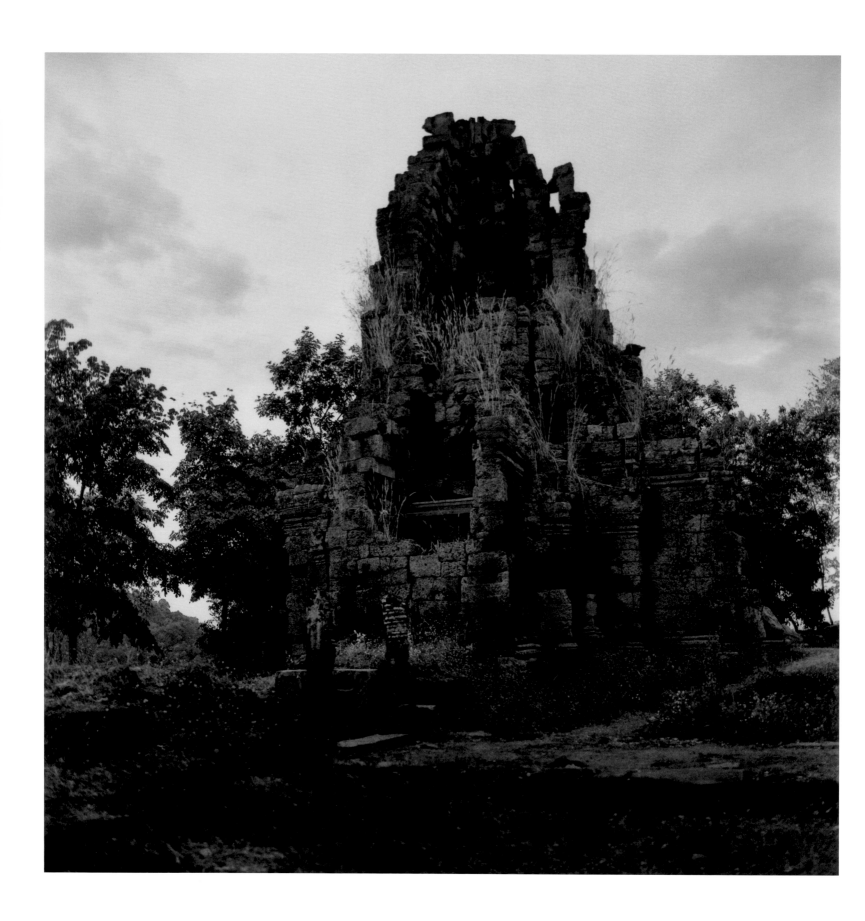

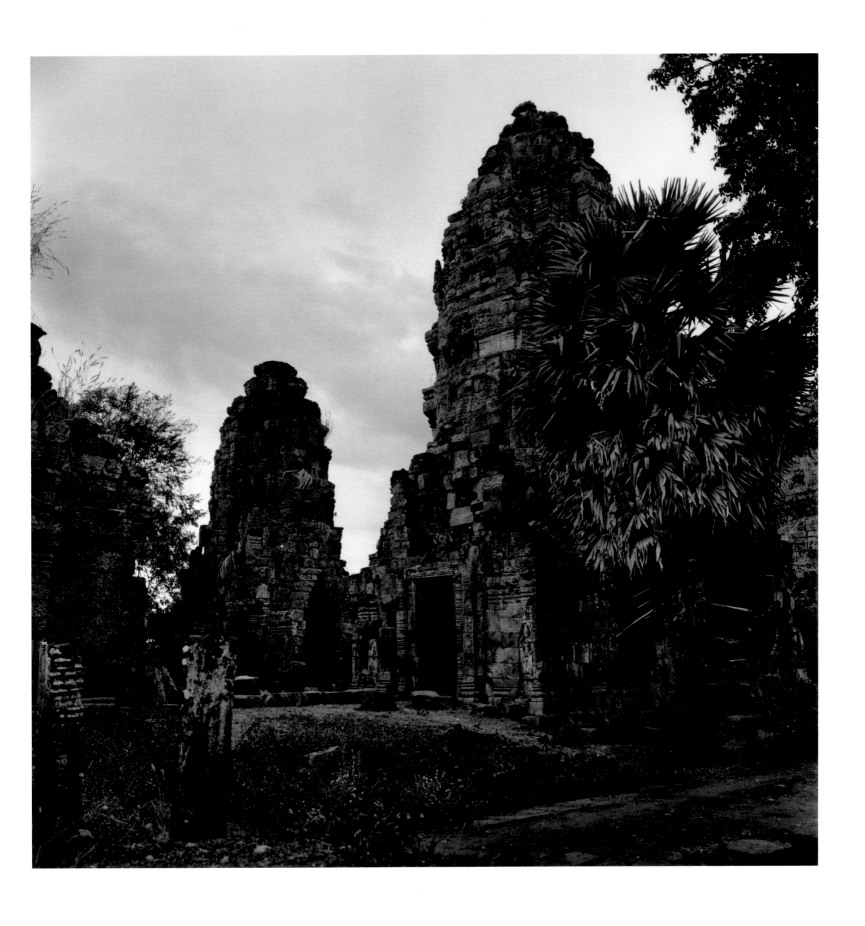

Wat Banan - south of Battambang where fierce battles were fought between Hun Sen Royalist troops and the Khmer Rouge.

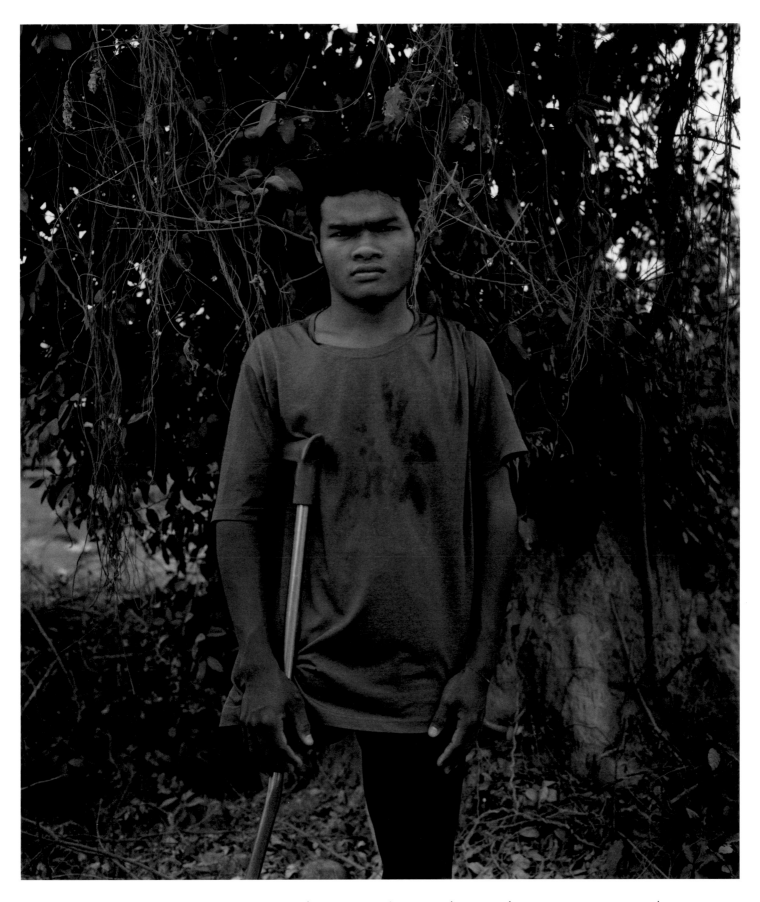

Muy Bel - The cows I was tending were trying to reach a grassy area that I knew was mined. So I ran ahead of them trying to head them off and hit a mine myself. A friend brought me to a small village clinic but they said I was going to die so refused me. Three days later my brother took me to a Siem Reap hospital. My mother died of lung disease. My father remarried, moved away with his new family and left me alone in our village. Someone took pity on me and raised me but I am unhappy not to have a mother and father.

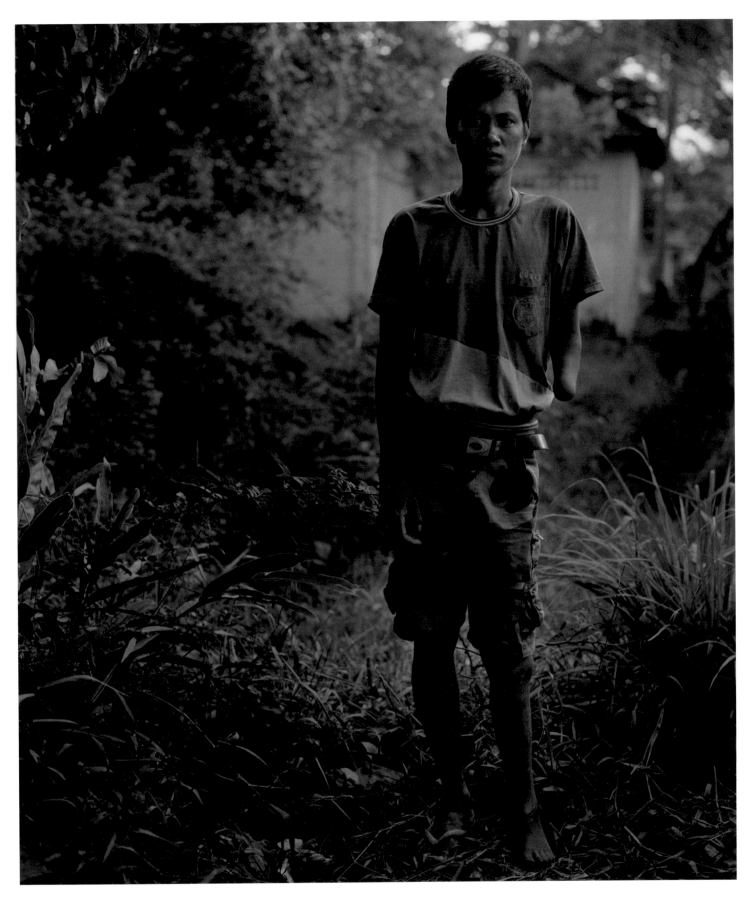

Mou Lin - I was a conscript in the Khmer Rouge army. In 1989 I was forced at gunpoint to disarm a mine which blew off my arm. I was so angry that I ran away to the Cambodian army. While I was in a military column in 1994 the first man in line hit a tripwire of a big mine. The first two men were killed, three of us were maimed. I lost my leg. My wife still cries very much.

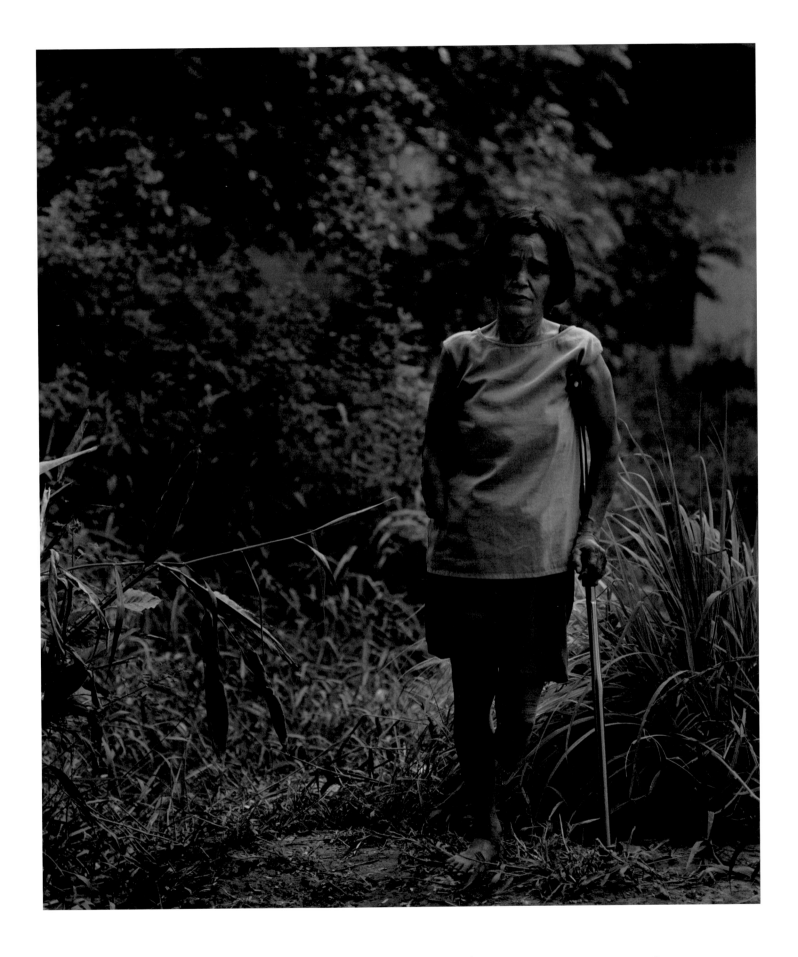

Krah Earn All I can do now is sit in the house and try to care for my grandchildren since I lost my leg and arm to a mine. I am teaching them about the danger of landmines and the destruction of war.

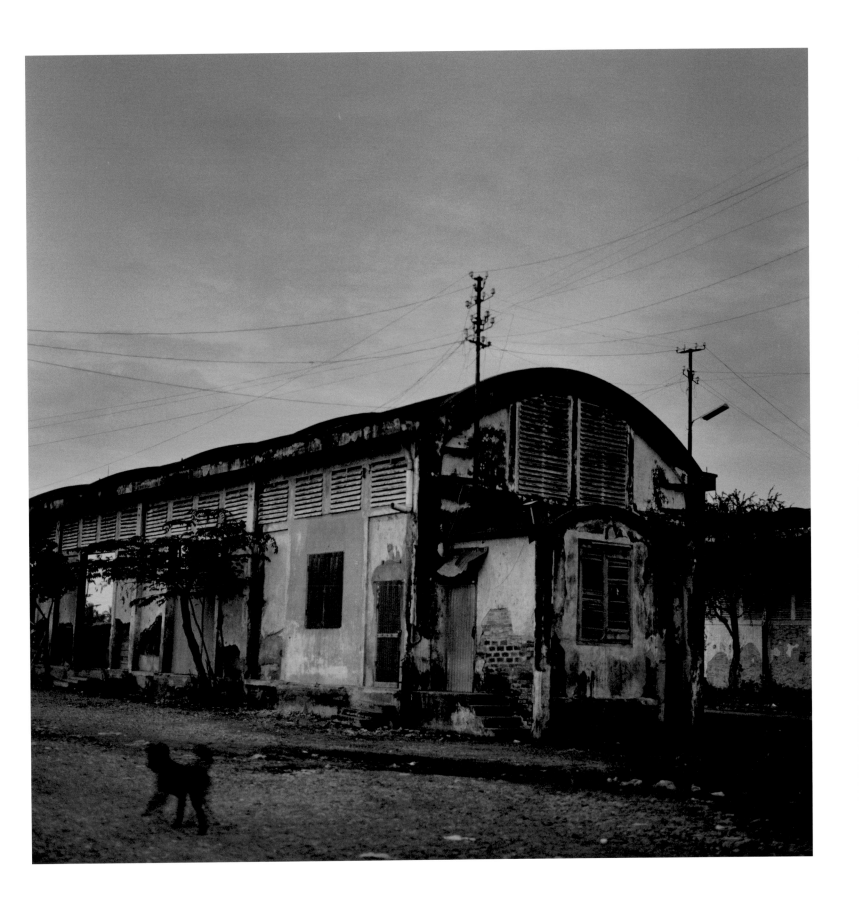

Battambang rail station — The trains were used for the transport of ammunition, troops and food. They were continually under attack either by bandits or various armies. To detonate the mines placed on the tracks two flat cars were attached to the front of the train. Passengers were allowed to ride on these first two cars free of charge.

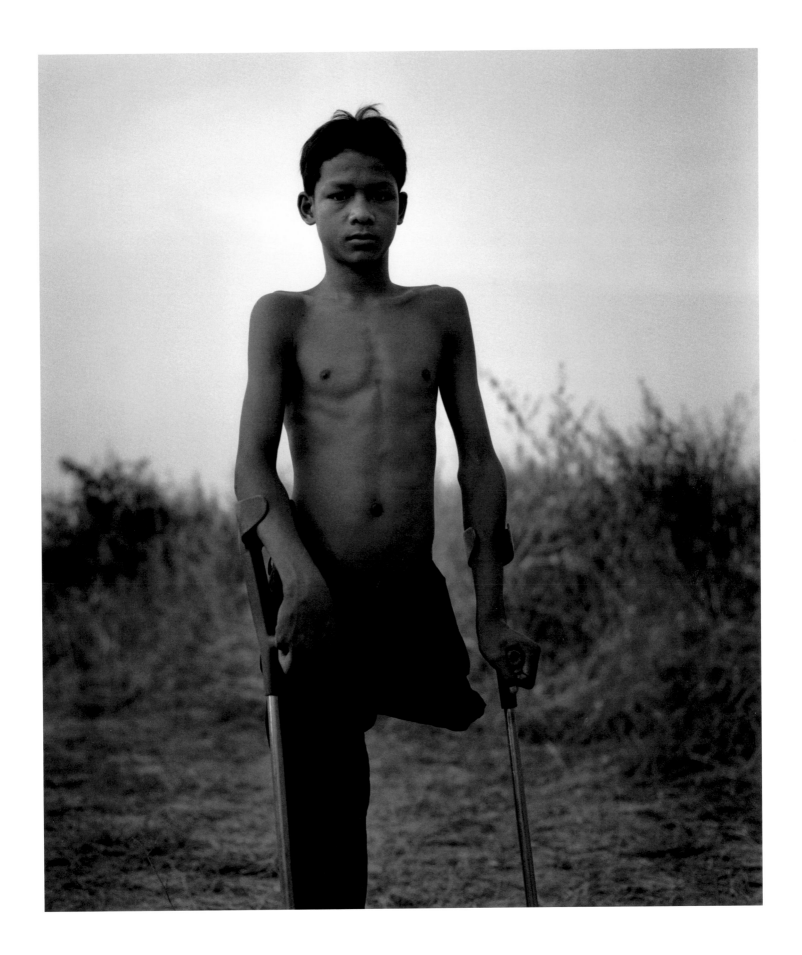

Poiy Yen - I was carrying wild pig meat back from the fields. Two
Khmer Rouge soldiers started walking with me in the cart track. I
was only seven so when the soldiers told me to walk ahead of them
I did. A mine shredded my foot so the hospital cut off my leg.

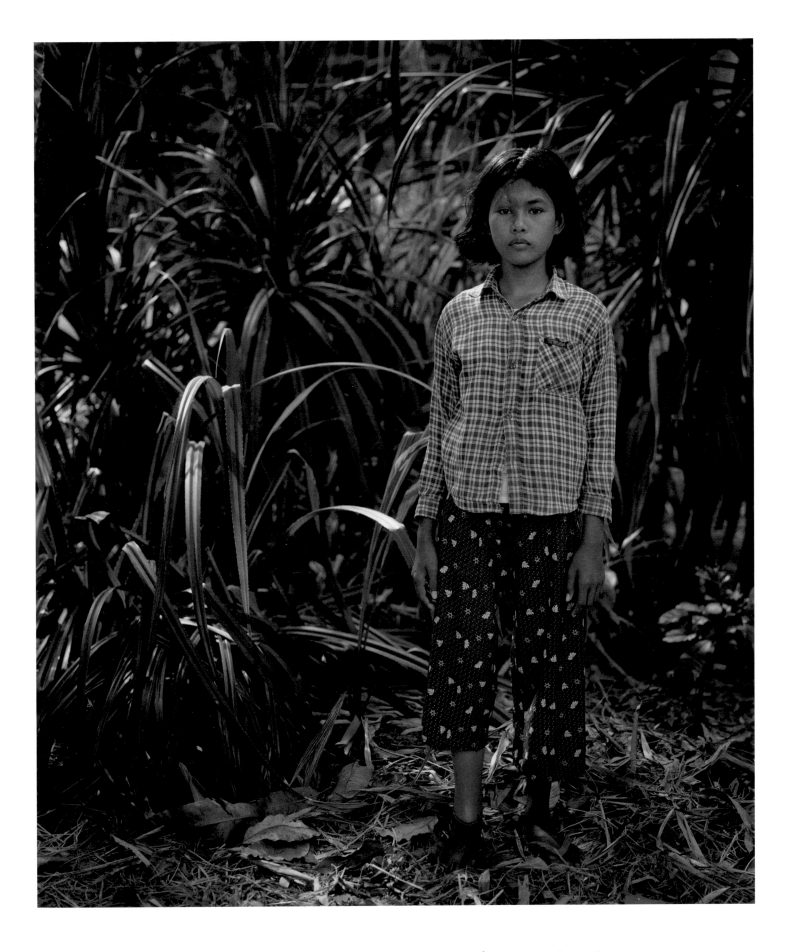

Khum Pha – There was a flock of birds I was chasing when I stepped on a mine. I lost my leg and wounded my face when I fell. Other children look at me funny because I am ugly now.

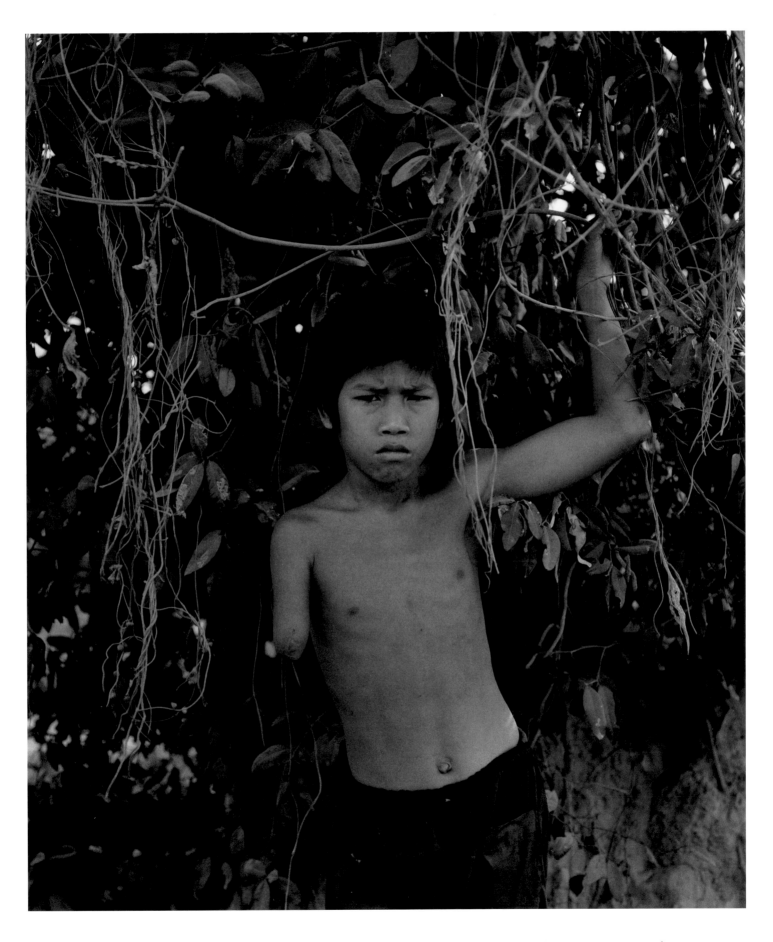

Bo Reac - I was throwing a rock at a chicken and hit a mine hidden in a big dirt clog. So I lost my arm and have a piece of metal in my eye. You can't see my arm is missing when I'm dressed. But when I'm playing with my friends and want to pretend to shoot a rifle, I can't.

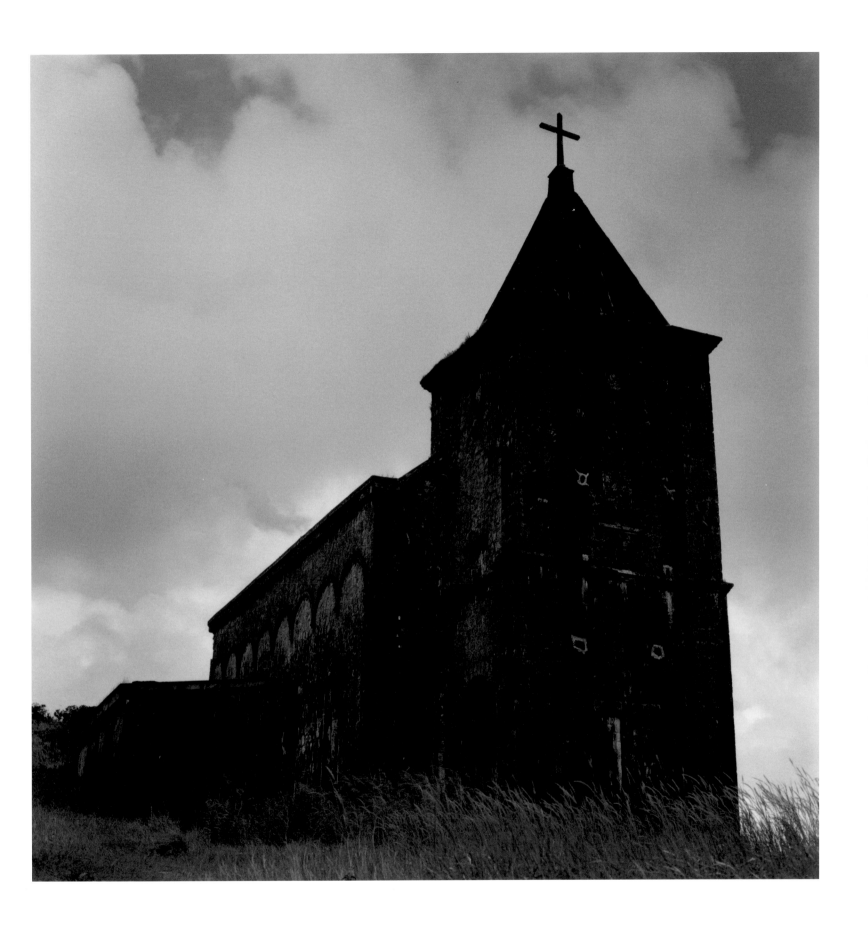

Catholic church on Bokor Hill where the Khmer Rouge in 1979 held out for months while the Vietnamese shelled them from the Palace Hotel, only about 500m away.

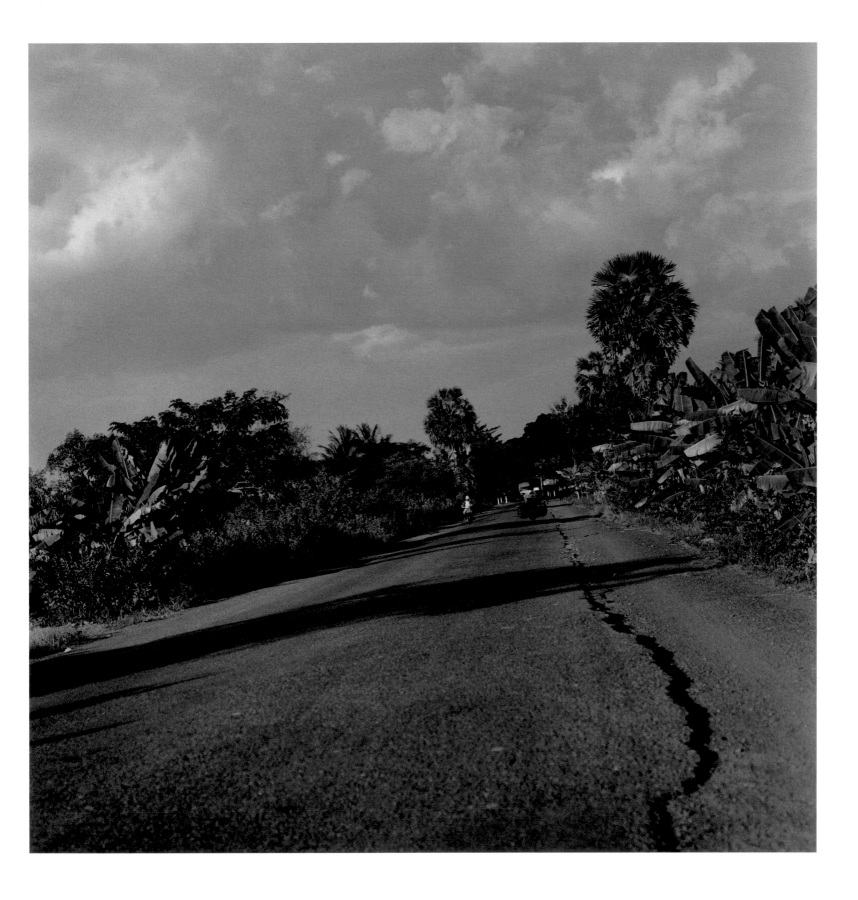

K-5, the world's longest minefield, about 1,046, long stretches from the gulf of Thailand to the Laos border. The minefield was an attempt by the joint forces of the Vietnamese and The Peoples Republic of Kampuchea to seal the border. Additionally, because Cambodia's northern region was a frontline between the government and the Khmer Rouge, that area became some of the most densely mined land on the planet.

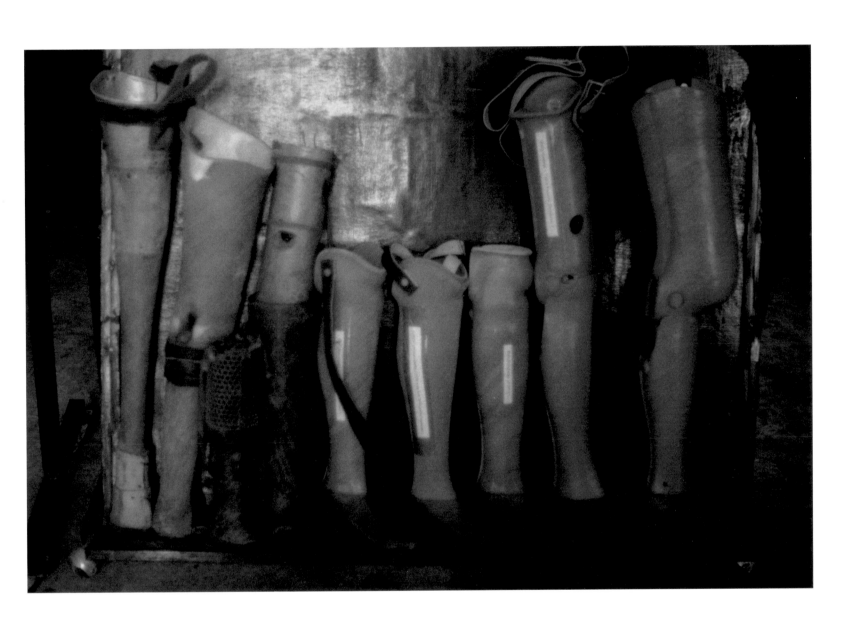

Legs and arms are made from bombs, shell casings, bamboo, rubber, wood and plastic.

More than thirty years after an estimated two million people died at the hands of Pol Pot's regime of Democratic Kampuchea, trials of senior Khmer Rouge leaders and those most responsible for the deaths are at last taking place in Cambodia. Sentenced to 35 years in prison for war crimes and crimes against humanity was Kaing Guek Eav, commonly known as Duch, the director of Security Prison 21, also known as Tuol Sleng, where at least 14,000 prisoners, mostly Khmer Rouge cadres and officials, were tortured and killed. Even more important, the next trial involves the four most senior Khmer leaders still alive: Nuon Chea, known as Brother Number Two; Ieng Sary, who was foreign minister; his wife, Ieng Thirith, minister for social affairs; and Khieu Samphan, who was president of Democratic Kampuchea. When they were arrested in 2007 and charged with war crimes, crimes against humanity, genocide and related crimes under Cambodian law, all four were in their late 70's and early 80's. While the trials have refocused international attention on Cambodia's dark past, little attention has been given to how the much-watched proceedings relate to the troubled politics of Cambodia today.

Cambodia is currently ruled by longtime Prime Minister Hun Sen and his Cambodian People's Party. They govern with absolute power and control all institutions that could challenge their authority. Opposition political parties exist, giving the illusion of multi-party democracy, but elections have not been fair and the opposition no longer poses any threat to Hun Sen. The monarchy has survived but has little influence. The free-doms of expression, association, and assembly are severely curtailed. Human rights organizations are intimidated, and a draft law aims to bring them under the regime's authority. The judiciary is controlled by the executive, and the flawed laws that exist are selectively enforced. Hundreds of murders and violent attacks against politicians, journalists, labor leaders, and others critical of Hun Sen and his party remain unsolved. The regime's violence against political opponents has been flagrant. In March 1997 Hun Sen's bodyguards were clearly implicated in a grenade attack on a peaceful rally

in Cambodia's capital, Phnom Penh, led by opposition leader Sam Rainsy. Sixteen people were killed and over 140 injured, including a US citizen. No serious inquiry was ever completed. Royalist opponents of Hun Sen were murdered when he deposed Prime Minister Norodom Ranariddh in a coup on July 5-6, 1997. More people were killed during the July 1998 elections, which Hun Sen won. In January 2004, the popular labor leader Chea Vichea, an outspoken critic of the government, was shot, one of several contract killings in Phnom Penh before and after the July 2003 elections, carried out in broad daylight by helmeted gunmen on motorbikes.

In October 2005, in an attempt to encourage prosecution of these murders and other serious crimes, Peter Leuprecht, at the time the United Nations secretary-general's special representative for human rights in Cambodia, issued a report tracing a continuing and accepted practice of impunity since the start of the 1990s. However, open discussion of the report and its recommendations was not possible in Cambodia and it was ignored. By confronting the crimes committed between 1975 and 1979, the Khmer Rouge trials offer hope of breaking the pattern of impunity that has characterized Cambodia's recent history. But they could also allow Cambodia's leaders to claim a commitment to justice and the rule of law while avoiding accountability for their own crimes and repressive practices.

Cambodia was once one of Asia's greatest empires. The only existing account of life in what we now call Angkor was written by Zhou Daguan, a Chinese envoy, after he spent almost a year there at the end of the thirteenth century. What he saw and described was an extraordinary civilization still at its height, the outcome of five centuries of political and cultural continuity. His stories are taught in schools and scholars draw on them to gain a picture of life and society in Angkor.

Angkor's ancient glory is reassuring to a people whose history after gaining independence from France in 1953 has been so perilous. Drawn into the cold war and the war against Vietnam, they endured the Nixon administration's covert and illegal bombing in the late 1960s in pursuit of the Vietcong; the overthrow of their head of state and former king, Prince Norodom Sihanouk, in 1970; and years of more bombing and civil

war that culminated in the Khmer Rouge taking absolute control when it captured Phnom Penh in April 1975 and founded the state of Democratic Kampuchea. It ruled until it was ousted in January 1979 by Vietnamese troops who installed the People's Republic of Kampuchea with Soviet backing.

Hun Sen, formerly a Khmer Rouge regimental commander who fled to Vietnam in 1978, emerged as a principal leader of the new government, serving first as foreign minister and then as prime minister. The Khmer Rouge, meanwhile, had retreated to camps on the Thai border, allied itself with other opposition forces, and continued to claim power. Since the US and other nations did not want to recognize a Cambodian government dominated by Vietnam, these disparate forces were supported and armed by China, the US, and Thailand, among others, and recognized by the United Nations as the legitimate government of Cambodia.

The end of the cold war, and exhaustion among Cambodians after so many years of war, made possible an internationally brokered peace agreement in 1991—the Agreements on a Comprehensive Political Settlement of the Cambodia Conflict—and the deployment a year later of the United Nations Transitional Authority for Cambodia (UNTAC), the largest peacekeeping operation the UN had ever mounted. UNTAC was charged with overseeing an end to armed conflict, disarming the armies of the fighting factions, repatriating refugees, and creating a neutral political environment for fair elections, which it was to organize.

The royalist party won the May 1993 elections. When Hun Sen threatened armed secession, a power-sharing arrangement was brokered to meet his demands, resulting in an unwieldy coalition government that he came to dominate. Cambodia became the Royal Kingdom of Cambodia under a new constitution, and Norodom Sihanouk returned to the throne. UNTAC left in September 1993, its departure dictated by the UN Security Council, not by conditions in Cambodia where violence and fighting against the Khmer Rouge, which had boycotted the elections, continued. For the outside world, the main objective had been achieved, namely to enable the former cold war powers to disengage from a country in which they no longer had any interest.

Today, for most foreigners, Cambodia seems to be a relatively stable country, hospitable to outside investment and welcoming for expatriates and visitors touring Angkor's temples and the killing fields. Hun Sen, now one of the world's longest-serving prime ministers, maintains good relations with China, Japan, the US, Australia, and France. Unlike the Burmese generals, he has managed to manufacture an outwardly acceptable face, and has used international assistance to gain legitimacy at home and abroad.

Taking credit for ridding Cambodia of Pol Pot and the Khmer Rouge, Hun Sen cooperates with the trials as long as they don't diminish his power. He talks of sustainable development and reducing poverty while he and his party have exploited the country's resources and pocketed the payoffs. He tolerates the UN human rights presence, provided it limits itself to overcoming the legacy of Cambodia's tragic Khmer Rouge past. He uses Pol Pot's record as the yardstick to measure progress, thereby making failure impossible. The trials reinforce this message. No outside governments care to ask too many questions. Their economic and security interests are more important, as Hun Sen knows, and human rights are treated as dispensable.

Some believe that sooner or later Cambodians will rebel, but it seems more likely that their discontent will instead be channeled into extreme forms of nationalism, as under the Khmer Rouge. Cambodia has been divided and preyed upon for much of its modern history. Many Cambodians fear Vietnam and Thailand as predatory neighbors, and passions against both countries can become quickly inflamed.

In the 1991 peace agreements, the "international community" assumed special responsibilities to the people of Cambodia that have yet to be properly honored. Cambodia today is a corrupt and cruel semi-dictatorship that should be getting much more scrutiny from the rest of the world. The Cambodian people deserve better. Thirty years after the appalling transgressions of the Khmer Rouge, much of the country still lives in fear.

Margo Picken, London, England

ព្រះរាជាណាចក្រកម្ពុជា

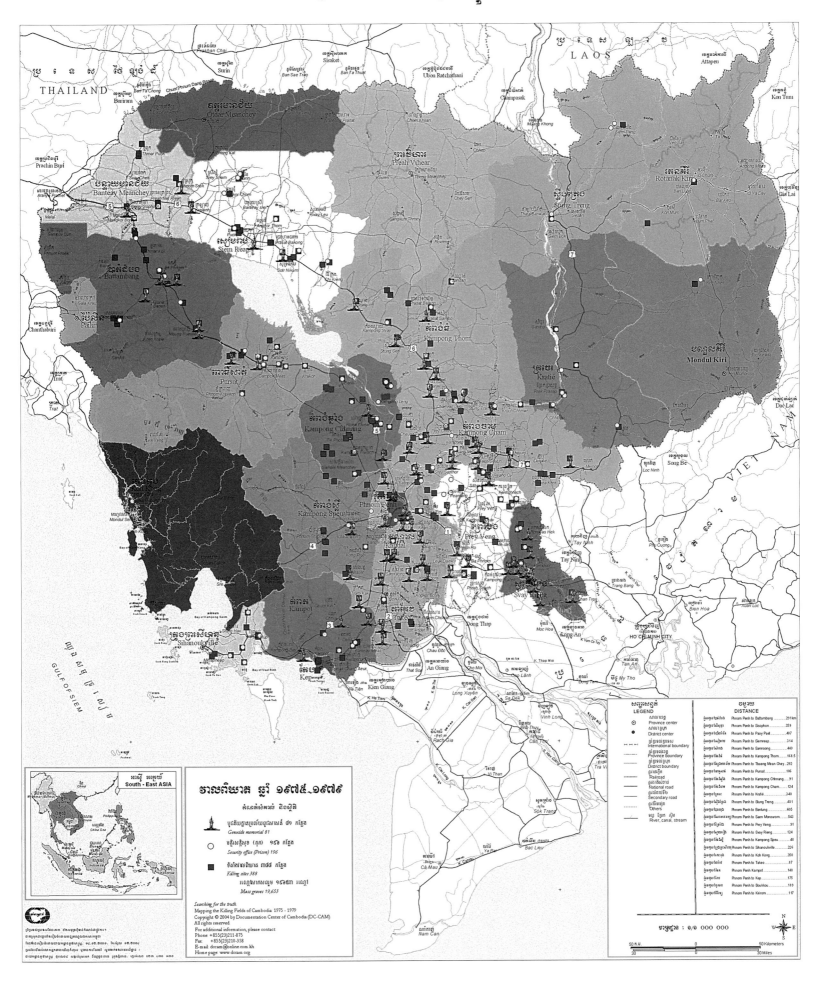

វាលពិឃាត ឆ្នាំ ១៩៧៥-១៩៧៩

គំនេរសំណាក់ ៦០ស្ថិត

🛕 បូជនីយដ្ឋានប្រល័យពូជសាសន៍ ៨១ កន្លែង
Genocide memorial 81

◯ មន្ទីរសន្តិសុខ (គុក) ១៩៦ កន្លែង
Security office (Prison) 196

◼ ទីតាំងសម្លាប់មនុស្ស ៣៨៨ កន្លែង
Killing sites 388
រណ្ដៅសពសរុប ១៩៦៧៣ រណ្ដៅ
Mass graves 19,653

LEGEND សញ្ញាសម្គាល់

⊙	ទីរួមខេត្ត Province center
●	ទីរួមស្រុក District center
	ព្រំដែនអន្តរជាតិ International boundary
	ព្រំខេត្ត Province boundary
	ព្រំស្រុក District boundary
	ផ្លូវដែក Railroad
	ផ្លូវថ្នល់ជាតិ National road
	ផ្លូវបង្គោល Secondary road
	ផ្លូវផ្សេងៗ Others
	ទន្លេ ព្រែក ស្ទឹង River, canal, stream

DISTANCE ចម្ងាយ

ភ្នំពេញទៅបាត់ដំបង Phnom Penh to Battambang	291km
ភ្នំពេញទៅស៊ីសុផុន Phnom Penh to Sisophon	359
ភ្នំពេញទៅប៉ោយប៉ែត Phnom Penh to Poiy Paet	407
ភ្នំពេញទៅសៀមរាប Phnom Penh to Siemreap	314
ភ្នំពេញទៅសំរោង Phnom Penh to Samraong	440
ភ្នំពេញទៅកំពង់ធំ Phnom Penh to Kampong Thom	168.5
ភ្នំពេញទៅត្បូងឃ្មុំ Phnom Penh to Tboeng Mean Chey	292
ភ្នំពេញទៅពោធិ៍សាត់ Phnom Penh to Pursat	186
ភ្នំពេញទៅកំពង់ឆ្នាំង Phnom Penh to Kampong Chhnang	91
ភ្នំពេញទៅកំពង់ចាម Phnom Penh to Kampong Cham	124
ភ្នំពេញទៅក្រចេះ Phnom Penh to Kratié	340
ភ្នំពេញទៅស្ទឹងត្រែង Phnom Penh to Stung Treng	431
ភ្នំពេញទៅបានលុង Phnom Penh to Banlung	695
ភ្នំពេញទៅសែនមនោរម្យ Phnom Penh to Saen Monourom	543
ភ្នំពេញទៅព្រៃវែង Phnom Penh to Prey Veng	91
ភ្នំពេញទៅស្វាយរៀង Phnom Penh to Svay Rieng	124
ភ្នំពេញទៅកំពង់ស្ពឺ Phnom Penh to Kampong Speu	48
ភ្នំពេញទៅព្រះសីហនុ Phnom Penh to Sihanoukville	226
ភ្នំពេញទៅកោះកុង Phnom Penh to Koh Kong	350
ភ្នំពេញទៅតាកែវ Phnom Penh to Takeo	87
ភ្នំពេញទៅកំពត Phnom Penh to Kampot	148
ភ្នំពេញទៅកែប Phnom Penh to Kep	175
ភ្នំពេញទៅបូកគោ Phnom Penh to Boukkou	189
ភ្នំពេញទៅកិរីរម្យ Phnom Penh to Kirirom	117

South - East ASIA អាស៊ី អាគ្នេយ៍

មាត្រដ្ឋាន : ១/១ 000 000

KILLING FIELDS AND PRISONS. AS OF 2007 THERE ARE OVER 388 SITES CONTAINING 19,733 MASS GRAVES. IN ADDITION, 196 KHMER ROUGE PRISONS HAVE BEEN IDENTIFIED.

ACKNOWLEDGEMENTS

Tom Carney for his invaluable notes, love and encouragement. Don McCullin for his many years of friendship, inspiration and generosity. Philip Jones Griffiths for his spirit and comradery, greatly missed. Elizabeth and Felix Rohatyn for their sustaining friendship. Sopheakr Vong Kry, my diligent translator. David Nuon and Sokun Mith, my intrepid drivers. Ouch Sary for opening some doors and his political insight. Matt Dillon and Fisher Stevens for sharing their Cambodian and Vietnamese contacts. Tony Nong in HCMC, Vietnam for excellent travel assistance.

For the incredibly stoic Cambodian people, who are still suffering, my admiration and respect.

For their patient assistance and hospitality when I would arrive unexpectedly at odd hours from a shooting to the following hotels and staff: Raffles Grand Hotel d'Angkor, Siem Reap; Raffles Le Royal Hotel, Phnom Penh; Sofitel Royal Angkor Hotel, Siem Reap; Sofitel Metropole Hotel, Hanoi, Vietnam.

Unha Kim, designer; Chuck Kelton, Kelton Labs, photographic prints; Joe Berndt, Bowhaus, print scanning; Danny Frank and Mike Page, Meridian Printing, printer; Acme Bookbinding, book binder; Mousume Sarkar, NY Copy Center, layout copies.

Many of the following Non-Profit organizations assisted me in this book's research. They need your support. Please contribute if you can. My thanks to the following:

DC-Cam (Youk Chhang)
ICRC: International Committee of the Red Cross
HIPRC: Handicap International Physical Rehabilitation Center (Sok Sophorn)
OEC: Operations Enfants de Cambodge (Tith Davy, Meas Vicheth, Toan Oudain)
Adopt-A-Minefield
CMAC: Cambodian Mine Action Center
MAG: Mines Advisory Group
Halo Trust
Battambang Emergency Hospital
ICBL: International Campaign to Ban Landmines (Megan Burke)
Cambodian Children's Fund
UNICEF
VI: Veterans International (Rithy Keo)
ARC: American Red Cross
CT: Cambodian Trust
Enough
Itaria Alpi Surgical Center, Battambang
Save Cambodia's Wildlife
The War Museum (Aki Ra)
CRC: Cambodia Red Cross